Sculpture in the Sun

Hawaii's Art for Open Spaces

Sculpture in the Sun

Hawaii's Art for Open Spaces

Georgia and Warren Radford

Photographs by Rick Golt

The University Press of Hawaii Honolulu

Manufactured in the United States of America

Library of Congress Catalog Card No.
77–92972

ISBN: 0–8248–0526–7

Contents

vi

Preface

Not long after becoming residents of Honolulu, we began to be aware of Hawaii's impressive assemblage of outdoor art, which was accessible to the public and provided a rich resource for the enjoyment of local citizens and visitors alike. Our interest prompted us to prepare a collection of these works which might be used as a reference and guide. Because of early statewide legislation, as well as civic and corporate interest and action, Honolulu is in the forefront of a growing number of cities in the United States to recognize the value of public art in the urban environment—its achievements in this area of civic concern are, therefore, particularly worthy of recording.

Our basis of selection, within the context of our own criteria of quality, was that the collection presented be representative and that the works be out of doors, within the stream of day to day life. In some cases, the interior of buildings with which the works are associated—schools, libraries, the airport, and executive offices of the State Capitol, for example—contain additional works of art, not here included, but of interest to the art lover.

In the photography, the intent has been to show the art in its relationship to the open space and human environment for which it was ultimately commissioned. The descriptive comments are not intended to be critically evaluative but rather subjective impressions with factual information for the interest of the observer, who hopefully, and most importantly, will experience and enjoy the works at first hand.

Acknowledgments

We extend our particular thanks to the artists themselves, who have been our major source of reference for the works of art. Living in Hawaii, where the main research was carried out, they were particularly helpful and hospitable in the true Aloha spirit. To Alfred Preis and the Board of the State Foundation on Culture and the Arts, we extend our gratitude for their interest in the project, the use of their office for research, and a photography grant which enabled publication of the book to move ahead rapidly. To the Honolulu Academy of Arts, for their permission to reproduce pictures of works in their collection, we also owe our appreciation. And lastly, to our friends in Honolulu whose enthusiasm for the book was a continual source of support, we offer our warmest *mahalo*.

Perspectives
Public Art in Hawaii

The rich variety of works of art that now enhance many of the parks, playgrounds, and urban open spaces of Honolulu and the neighbor islands is a phenomenon almost entirely of the last decade. They typify a renaissance, occurring in many cities, of the placement of sculpture, fountains, or murals in public spaces—a tradition in which many of these monuments, through the years, acquired great affection and, as the Trevi Fountain of Rome, the Little Mermaid of Copenhagen, or Ariel in Piccadilly Circus, became symbols of civic identification. Long established in Europe, the custom flourished in the United States in the historical and commemorative sculpture of the nineteenth century. In Hawaii, however, which was late in westernization, such precedents hardly existed. The works presented in this collection, therefore, derive from many cultural roots, some unique to these islands, and from unique regional conditions. They also reflect new public and corporate attitudes toward the sponsorship of artists and public art.

Before 1820, the arts of Hawaii were highly developed within religious and utilitarian traditions. A dominant visual expression was sculpture, which was ritualistic in function. Large temple images, carved of wood, represented cosmic deities and served as the focus for the ceremonies taking place out of doors on the platforms of the *heiau*s. With heights of up to fifteen feet or more, these were impressive figures. Legs and arms strongly articulated, with prominent chests and elaborate headdresses, they were powerful volumetric compositions, and the play of sunlight on their faceted and deeply carved surfaces would have increased the visual impact. Secondary images, with less significant roles in the religious hierarchy, were smaller; some were portable, as required by ritual. All religious carving was assigned to the *kahuna*s, or artisan priests, and executed within a strict system of convention and symbolism.

The functional arts of making mats and *kapa* cloth, basketry, featherwork, and tattooing all employed a rich and refined decorative style, mostly geometric in character. A tradition in functional sculpture also flourished—small animal and human figures were carved with great ingenuity and humor, in a variety of attitudes, as supports for canoe paddles, spears, drum bases, and food bowls. In these pieces, the artists exhibited an inventiveness and playfulness not seen in the formal images of the temples. Petroglyphs—symbolic linear designs of men, animals, and objects (since the ancient Hawaiians had no written language)—were carved on boulders and rock surfaces. Those near trails and resting places were believed to represent events important to travellers. This iconography, along with the other secular arts, certainly contributed to the artistic heritage of Hawaii, and to the works of contemporary local artists.

The indigenous traditions came dramatically to an end in 1819, within six months after the death of Kamehameha I. Along with the breakdown of the system of religious law, Liholiho, Kamehameha II, ordered the destruction of the temples and their thousands of images. As a result, less than one hundred and fifty of these dynamic sculptures survive to this day. The primary motivating force for creative expression had been removed, and the Europeanization of life also began to affect the vitality of the secular carving and of all the other crafts. The introduction of cloth along with the termination of the religious ceremonies diminished the need for *kapa* and featherwork. These crafts gradually lost their function and no longer existed after the 1870s. Petroglyphs were supplanted by the Roman alphabet. In effect, the ancient culture had been overwhelmed, and with it, the visual arts virtually disappeared.

The turbulent political, social, and economic changes that rapidly occurred as the Hawaiians in the early days of the monarchy sought to maintain their independence left little time for artistic expression, either private or public. With the accession of Ka-

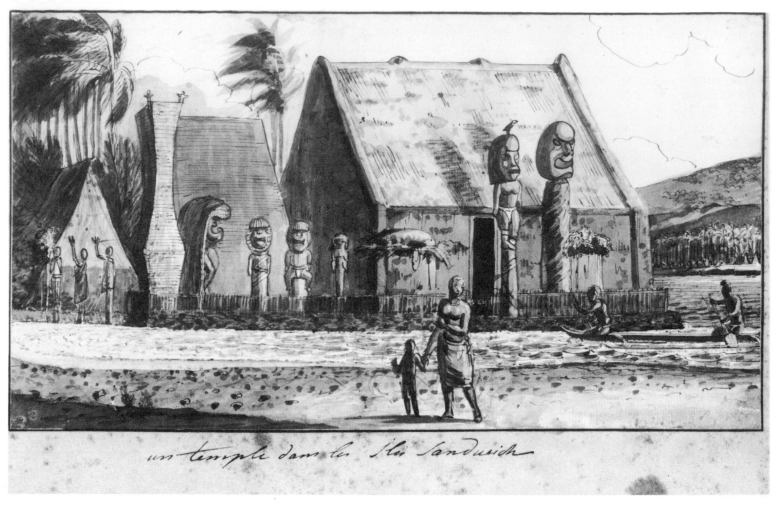

un temple dans les Iles Sandwich

LOUIS CHORIS (1795–1828), Russia, *Un temple dans les Iles Sandwich,* "A
temple in the Sandwich Islands"; watercolor, H.6-⅝", W.12"; Honolulu
Academy of Arts; Gift of Honolulu Art Society, 1944 (12,160)

mehameha IV, the monarchy at least seemed to be established. Twenty-seven years later, King David Kalakaua, celebrating his adoption of royal absolutism (after his tour of the kingdoms of the world), and affirming the traditions of the Hawaiian heritage, built the Iolani Palace and arranged an elaborate coronation on the ninth anniversary of his accession. The event was commemorated by the commissioning of a monument—a statue of Kamehameha I—which was also intended to celebrate the centennial of the "discovery" of the Sandwich Islands by Captain Cook. In 1883 this new image, of great symbolic significance to Hawaii, was unveiled before the Alliiolani Hale—after a hiatus in the arts of sixty years.

Through the turn of the century, and annexation in 1900, major public monuments remained scarce in Honolulu. As Buddhist and Shinto temples and shrines began to appear with the flow of immigration from the Orient, their religious images added color to the fabric of Honolulu's cultural life and visual character. In 1919, the Phoenix Fountain, a gift of the people of Japan, was placed in Kapiolani Park, and during the 1920s, a plaster copy of the Winged Victory of Samothrace dominated the portico of the Hawaii State Library (neither of these sculptures exist today). Commemorative plaques were placed around the city, dedicated to famous people and historic events. The Castle Fountain, built in 1932 in the midst of the banyan trees in Thomas Square, added a new dimension to the nighttime scene with its flood of varicolored lights playing on the forty-two-foot water jet. Other outdoor works were added in the mid-thirties—Marguerite Blasingame's marble reliefs and flagstone floor carvings at the McCoy Pavilion in Ala Moana Park, constructed under the Federal Emergency Relief Administration, and her panels for the fountain at the Kawananakoa school ground in Nuuanu.

It was also in the 1920s and 1930s that the buildings of Honolulu began to assume a distinctive regional char-

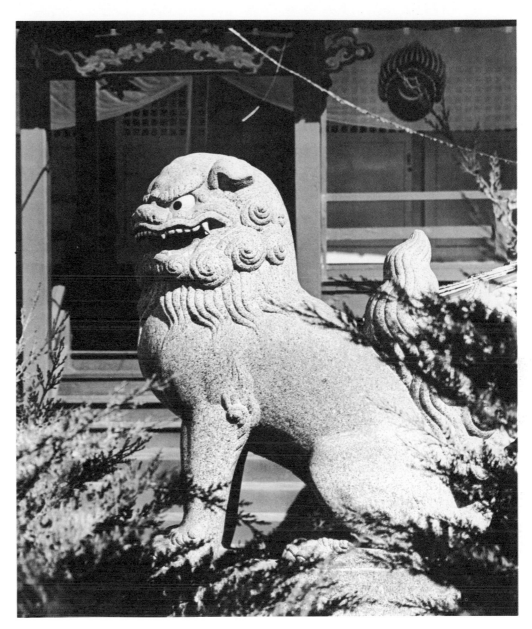

Stone image, Inari Jinsha Shrine, 2132 South King Street, Honolulu, 1914

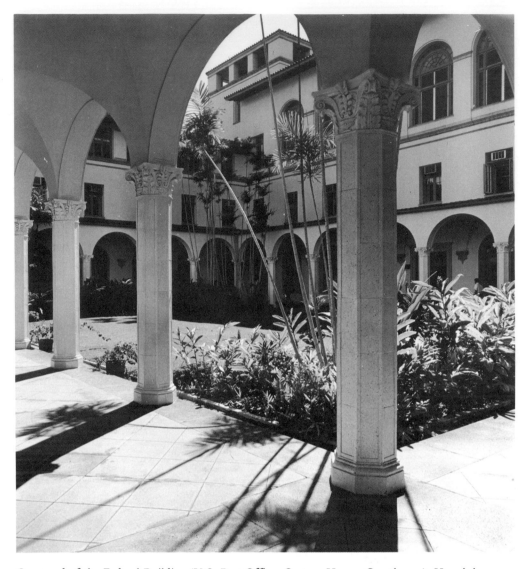

Courtyard of the Federal Building (U.S. Post Office, Custom House, Courthouse), Honolulu.
Architect: York & Sawyer, 1922

acter. The distinguished civic, corporate, and institutional architects of this period, sensitive both to the special qualities of Hawaii's climate and to its oriental heritage, began to incorporate outdoor spaces in their buildings—spaces which would become naturally graced by Hawaii's lush variety of trees and plants. The use of courts, collonades, terraces, balconies, and generous protective roofs incorporated the out of doors as an important building element. The play of decorative detail in relief, ceramic tile work, wrought iron grilles, and carved doors and screens against light-colored flat surfaces of stucco and plaster enlivened streets and open spaces. Buildings such as the Federal Building, comprising the United States Post Office, Custom House, and Court House (York and Sawyer); Honolulu Hale (Miller, Dickey and Wood); the offices of C. Brewer & Company (Mayers, Murray & Phillip); The Alexander & Baldwin Building (C. W. Dickey and Hart Wood); the Young Women's Christian Association Building (Julia Morgan) with its fine interior court and pool; and the Honolulu Academy of Arts (Bertram Goodhue) succeeded, by their grace, attention to scale and detail, and relaxed functionalism, in imparting aesthetic individuality to the downtown areas of the city.

Though the depression and World War II virtually halted the continued development of the trend, these buildings did establish precedents for the concern for the urban environment which was to follow in later years. Meanwhile, by mid-century the interest in public art began to quicken, resulting in many commissions. Outdoors, Honolulu had its first open-air frescoes in 1951, in the interior courts of Bilger Hall, the chemistry building on the Manoa Campus of the University of Hawaii. In these works, Juliette May Fraser, David Asherman, Sueko Kimura, and Richard Lucier, who had worked with Jean Charlot in the fresco technique (which he first used for his Bachman Hall frescoes), depicted the classic

elements of air, water, earth, and fire. In 1958, a second monumental statue was commissioned in Honolulu, this time to a Christian saint. Today, the bronze figure of St. Andrew, by the famous Yugoslav sculptor Ivan Mestrovic, stands in the Cathedral close, across the Capitol grounds and the Palace square from its predecessor, King Kamehameha I.

The period of the 1960s saw rapid transformation in the character and scale of Waikiki. The proliferation of high-rise hotels, the apartments and condominiums along the Ala Wai Canal, and the office buildings, shops, and restaurants of Kalakaua Avenue responded in design to the romantic mood of the vacationer. Their signs, decorations, and architectural details, drawing heavily on Polynesian motifs, produced a lively visual impact, now a characteristic of the fabric of Hawaiian life.

In the 1960s, unprecedented growth also occurred in downtown Honolulu, producing radical changes in the physical environment. Fortunately, much private and civic building and planning demonstrated renewed sensitivity to the urban environment by the inclusion of open spaces for public use. The concept, of course, was not new. Public spaces in cities were historically the focus for the varied activities of urban life—they set its tone and gave it vitality. These spaces, whether monumental or intimate in scale, were also recognized as a natural setting for sculpture and fountains. Fountains especially combining both audio and visual qualities, have traditionally satisfied the deep human needs of city dwellers in warm climates. Examples of this new regard for open space are found in a number of developments in Honolulu. The Hawaii State Capitol development, created by the closing of Hotel Street, was a fine open continuation of the Iolani Palace grounds, which was then extended across Beretania Street by the Armed Forces Memorial plaza. The River Street Mall, a project of the Honolulu Redevelopment Agency, exploited the natural amenities of the Nuuanu

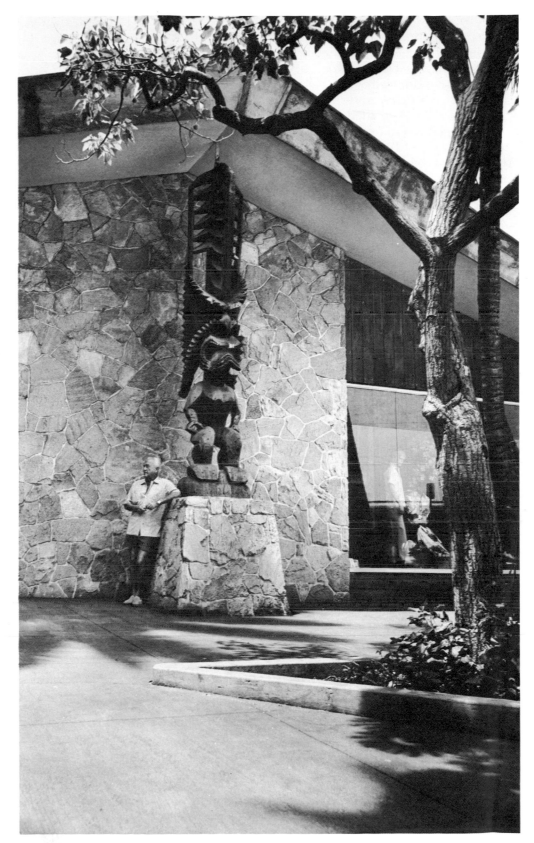

McInerny store, Kalakaua Avenue, Waikiki

Stream to provide a water-oriented, two-block-long linear park for quiet recreation, visiting, and promenading, as well as an agreeable setting for new commercial development. The Financial Plaza of the Pacific and the Pacific Trade Center Mall—smaller-scaled pedestrian plazas—and the Walker Park at the foot of Fort Street are privately financed open spaces for public use, as are the pedestrian concourses and courts of the Ala Moana Center. The Fort Street Mall, developed jointly by the City and County of Honolulu and the business community, is a highly successful amenity, providing shoppers freedom from auto traffic and the opportunity for rest and change of pace. These examples have incorporated landscaping, well-designed street "furniture," fountains, and works of art for the enjoyment of the public. In so doing, they confirm the notion of outdoor urban space as an important domain of the artist and sculptor.

A significant characteristic of contempory sculpture has also had an impact on its function in public places. Traditionally, public sculpture—representing historical, religious or literary themes, and primarily related to the human form—was placed upon a base or pedestal separating it from the observer. Today, most sculpture speaks for itself in form and materials. Without a base, it shares the viewer's space, inviting intimate reaction by its proximity. Most of the works presented here possess this quality of accessibility to a marked degree, and many have been created specifically for physical participation.

Concurrently with the responsive developments in the physical planning of downtown Honolulu, legislation was passed of great significance for the cultural environment of Hawaii. In 1967, the state legislature enacted Act 298, which requires that one percent of all appropriations for the construction of state buildings be used for art acquisition. The act is administered by the State Foundation on Culture and the Arts, in collaboration with the Department of Accounting and General Services, and is implemented through the Art in State Buildings program, responsible for the planning, commissioning, acquisition, and placing of works of art in spaces at state buildings, the State Capitol, and the Honolulu International Airport. Final selection of artists and their works is made by the Board of the State Foundation, acting upon recommendations of advisory panels composed of project architects, designers, client representatives of the using agency, and representatives of the neighboring community. Since the first commissions awarded in 1969, the State Foundation on Culture and the Arts has, to date, commissioned approximately two million dollars of original art. Under the leadership of Alfred Preis, F.A.I.A., executive director, the Arts in State Buildings program has introduced to the public a wide spectrum of contemporary art, by artists of both international and regional cultural background, both through its commissioned works and through portable works acquired for rotation within the state building system. Further, the encouragement of local artists, as well as the early exposure of young people to the arts, is being successfully accomplished by the combined activities of the Artists in Schools program with the Art in State Buildings program. These programs have been responsible for many works of art in the schools of Oahu and the neighbor islands, from which children have gained appreciation and enjoyment by active participation.

The sponsorship of public outdoor art in Honolulu has recently occurred at both city and federal levels, in the commissioning of a work to be placed in the vicinity of the new municipal building housing city offices. The sculpture is to be jointly funded by the "Works of Art in Public Places" program of the National Endowment for the Arts and the city of Honolulu, under a program which in 1974 dispensed some seven hundred thousand dollars in matching grants. The artist, Isamu Noguchi, an internationally known Japanese-American sculptor, was selected by the City Commission on Culture and the Arts and representatives of the National Endowment for the Arts. Also contributing toward several new works in the new federal building in Honolulu will be the Fine Arts Program of the General Services Administration, responsible for buildings of the federal government, which allocates one-half of one percent of construction costs for art, and at present has awarded more than twelve million dollars of commissions from Honolulu to Philadelphia. Programs such as these are now contributing to the public art movement in many cities—Boston, Chicago, Washington, D.C., Grand Rapids, Denver, and San Francisco, as well as Honolulu.

It is to be hoped that these programs and sponsorships will continue in the future. In Hawaii, they can become a significant aspect of the pressing concerns for urban livability and the quality of environment in the Islands. There are many opportunities, many areas that may be humanized by the introduction of visual variety and enrichment—neighborhood shopping centers, the recreational areas of housing developments, hospitals, public housing, and housing for the ill and aged, to name only a few.

If it has been thought that the world of contemporary art has been too inward looking, and artists too subjective in their perceptions to achieve communication, the placing of art in public spaces may herald a new rapport, to the benefit of citizen and artist alike. Sculptures, fountains, and murals will be enjoyed in a self-related way, literally, without the need for esoteric explanation. By sharpening the senses, they will provide an antidote for the accommodation to ugliness. And it seems appropriate that in Hawaii, because of its natural beauty and tempo of life, this renaissance should be so outstandingly successful.

W.H.R.
May 1976

Using this book

All the works of art in this volume are located on the island of Oahu in Hawaii. Preceding the descriptive comments for each work are several lines of introductory information containing the name of the artist, the name of the work and the material it is made of, and the date of installation or purchase. The location* and address of each piece follows, along with the name of the commissioning agent, purchaser or donor. The general area in which the work is located is noted at the bottom of the page, that is, downtown, Ala Moana, Thomas Square. Though many of the works are separated by some distance, the greatest concentration is in the downtown area (over a fourth of this collection). A map of this section, with keyed locations, is provided. All the works are presented in a sequential manner, proceeding first from the downtown area, toward Diamond Head and Koko Head, and then toward Ewa and Leeward Oahu. The sequence of the art on the University of Hawaii, Manoa Campus, is arranged for a walking tour, beginning near the East-West Center.

* The old Hawaiian directional devices of *mauka* (toward the mountains), *makai* (toward the sea), *ewa* (roughly northwest), and Diamond Head (roughly southeast) are employed here; they are more effective in an island environment than the traditional compass points.

Sculpture in the Sun

Hawaii's Art for Open Spaces

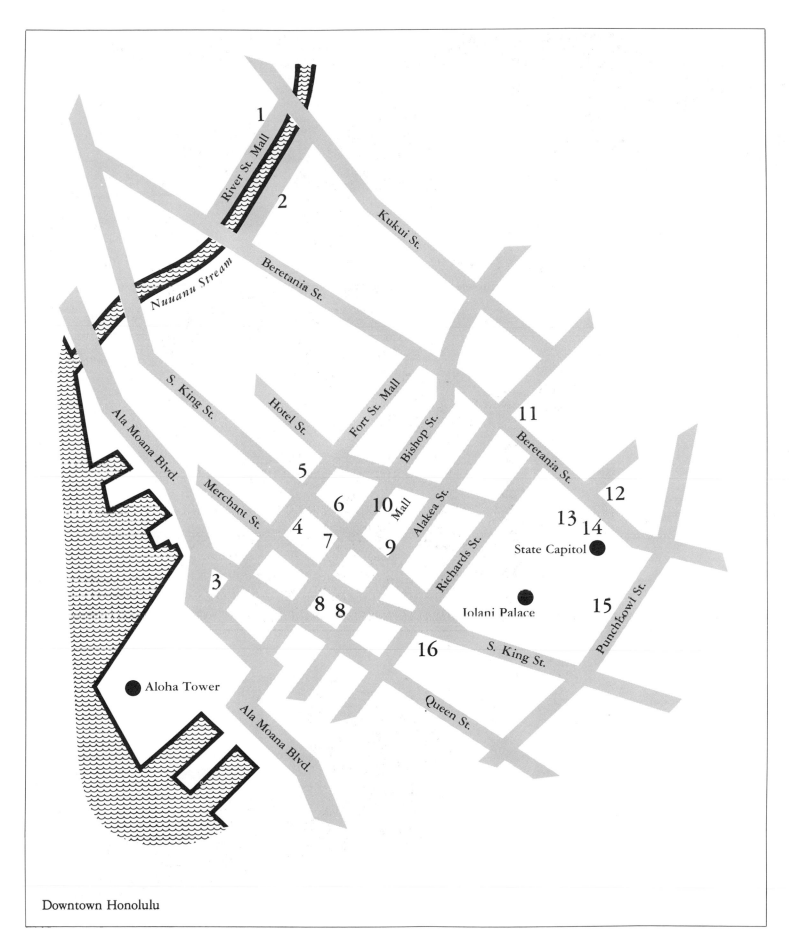

Downtown Honolulu

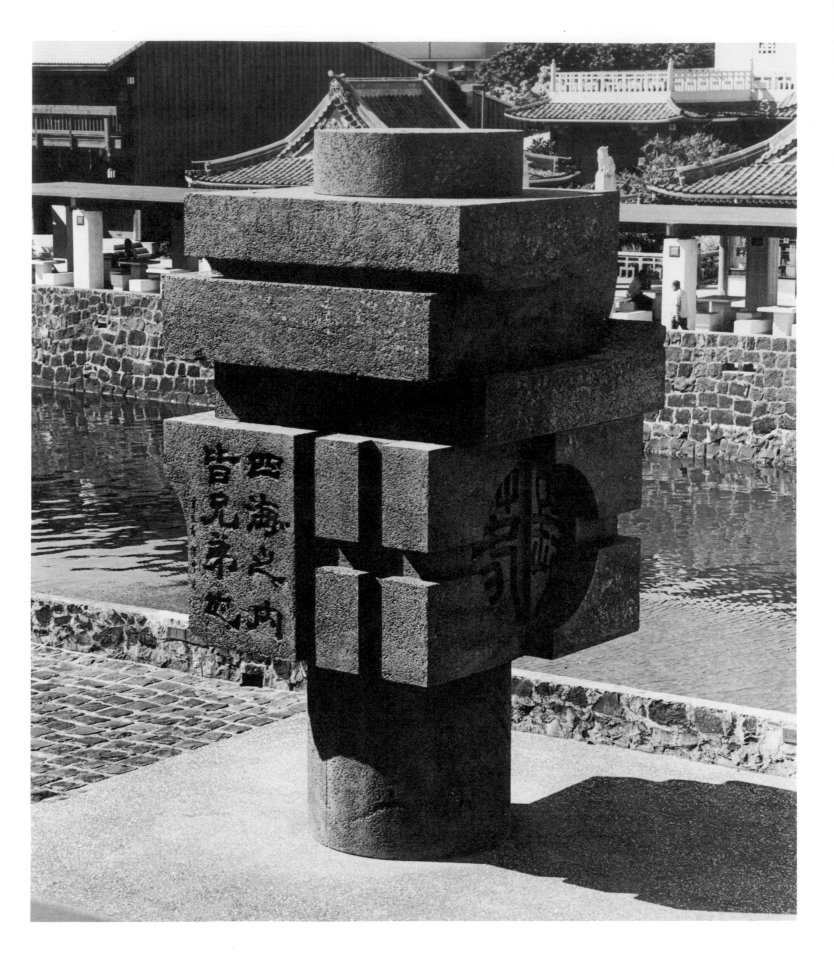

4

Edward M. Brownlee

T'Sung

Cast stone. 1971

Gateway

Cast stone, stainless steel. 1971

River Street Mall, Honolulu

Commissioned by Honolulu
Redevelopment Agency

Two contemporary works of Edward Brownlee provide dramatic symbolism and focus for the River Street Mall, a redevelopment project of the City of Honolulu consisting of a linear park bordering both sides of the Nuuanu Stream and encompassing part of the area commonly known as Chinatown. *T'Sung,* a monumental abstract sculpture nineteen feet high and the larger of the two, is placed on the Diamond Head side of the stream, where the mall is fronted by a new business area. Its title refers poetically to the forms of ancient Chinese earth symbols, appropriate to the site where immigrants from the Orient first entered Hawaii. Five rectilinear, layered slabs of dark cast stone with volcanic aggregate are welded to a steel core and appear to be pierced by a massive column resting on a low horizontal base. Bold script designs, cast into the concrete and expressing philosophic vignettes of the poets and philosophers of China's dynastic past, were executed by the distinguised calligrapher Shen C. Y. Fu of Taiwan.

As a signpost to the mall on the *ewa* side, adjacent to the Izumo Taishakyo Mission (a Shinto temple), stands *Gateway,* a more intimate work in scale and feeling. Of the same material as *T'Sung,* it is cast in one piece, with a broad rectangular base and block seats on the river side. The character of *Gateway* seems to derive from the heavy wood beams of Japanese architecture with their traditional end caps translated into highly polished stainless steel, lightening the sculpture with brilliant reflections of sky and trees. The blue basalt stones of the handsome paved surfaces of the mall surrounding both sculptures were once used as linings for the old canefield ditches of Oahu.

Downtown

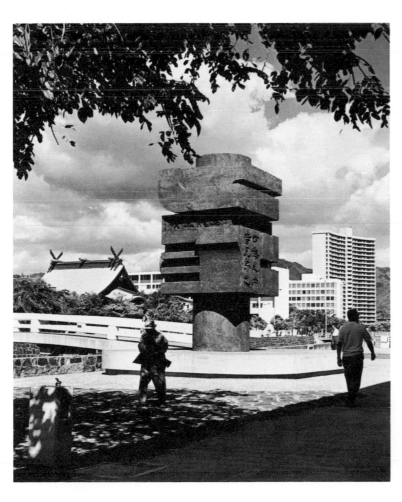

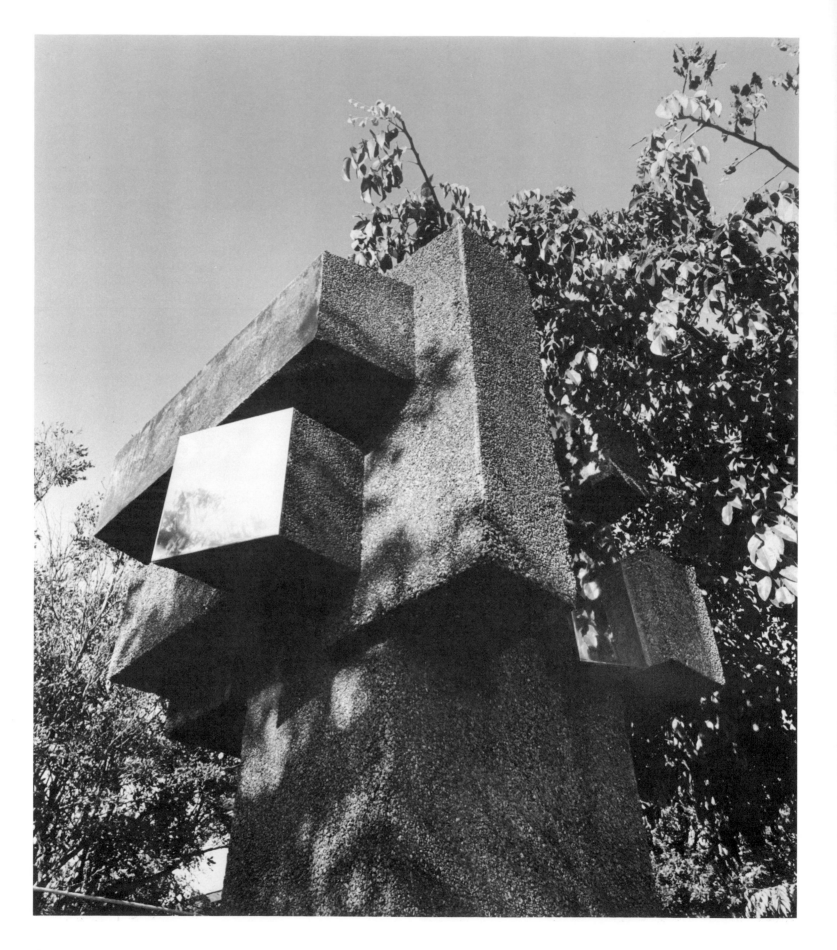

6

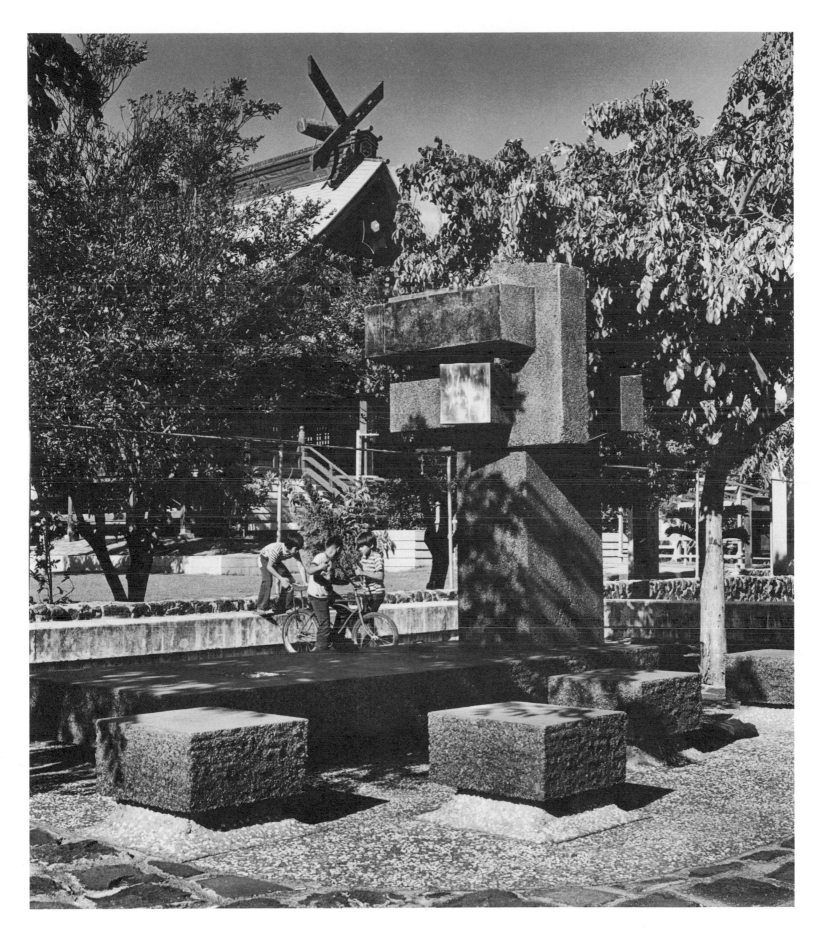

William D. Podesto, A.I.A.; Anthony M. Guzzardo & Associates

Walker Fountain

Concrete pavers, bronze. 1972

Walker Park, foot of Fort Street Mall, Honolulu

Park Project commissioned by Center Properties

Funds for fountain donated by family of H. Alexander Walker, Sr.

One of the most successful open spaces of downtown Honolulu is the Walker Park at the foot of Fort Street Mall, which provides a link between the famous Aloha Tower and its plaza across Dillingham Boulevard, and the newer buildings of the financial section. Adjacent to the Hawaii Building of the Amfac Center and the historic headquarters of C. Brewer and Company, this small, grassy, shaded park is a popular noontime gathering place. Its focus is an elegantly simple fountain with three clusters of bronze water jets, set in a rimless pool and surrounded by twelve concrete bollards. The paved area surrounding the fountain dishes down to form the pool basin, defined by concentric offset circles of alternately recessed pavers that form a checkerboard pattern. Optical effects, called *moiré* patterns and caused by the superimposition of curves, can be easily observed. Adjacent to the fountain are the ornate iron gates (restored and painted with red and lavender bands in the capitals) which for fifty years stood at the Queen Street headquarters of H. Hackfeld & Company, Ltd., now known as Amfac, Inc.

Downtown

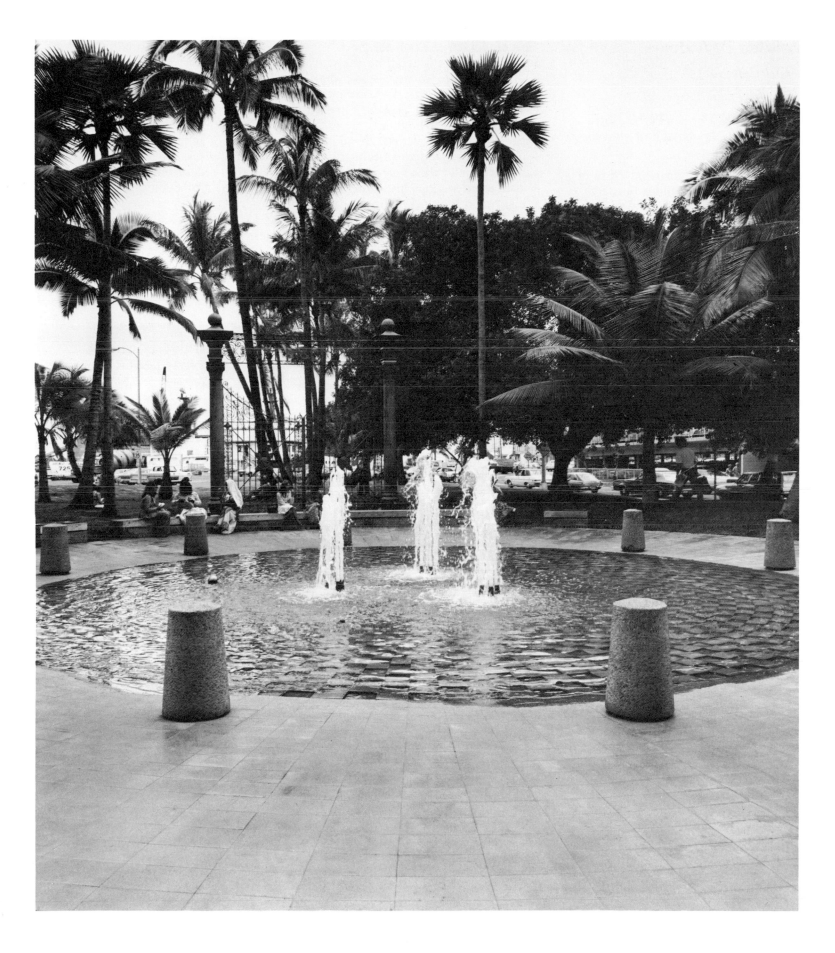

Arnaldo Pomodoro

Three Columns

Bronze, concrete, steel. 1970

Financial Plaza of the Pacific, Fort Street Mall side of Bank of Hawaii Building

Commissioned by Financial Plaza of the Pacific Condominium Owners

This enigmatic composition of columns, thematically recalling the sculptor's native Italy, relates comfortably to the confined, vertical setting of the plaza of the Bank of Hawaii. Three interpretations of the theme are expressed through materials, detail, and finish. Of the two sixteen-foot columns, one is of dark gray concrete, with stacked sections intricately cast in intaglio and interlocked by anodized steel bands; the other, a vertical shaft of brilliant polished bronze, is rent by jagged openings exposing interstices of metal inserts ranged with mechanical precision. The third, smaller than the others, is a "sliced" column of stainless steel, its perfection thereby destroyed, yet elegantly finished in muted pale gold with chromed cross sections. Each piece evokes its own response. They relate to each other by the compelling craftsmanship of this sculptor, who at one stage of his career was a practicing jewelry designer. The columns were cast in Italy and installed by Valdastri, Ltd., of Honolulu.

Downtown

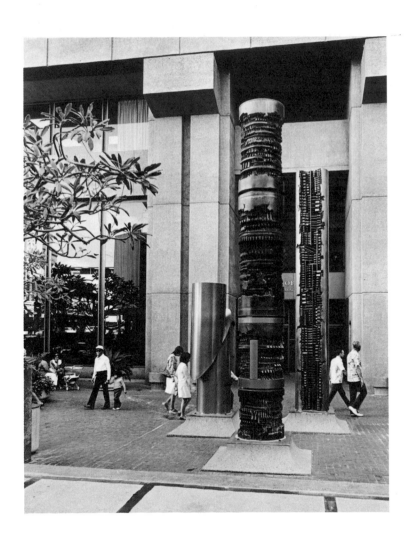
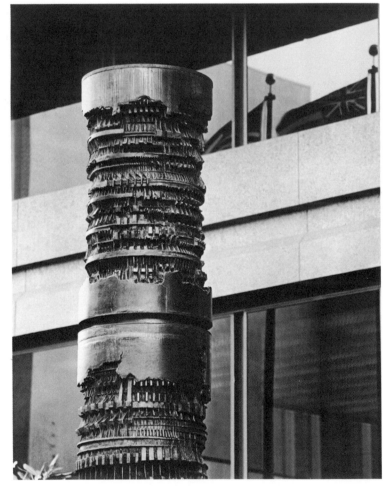

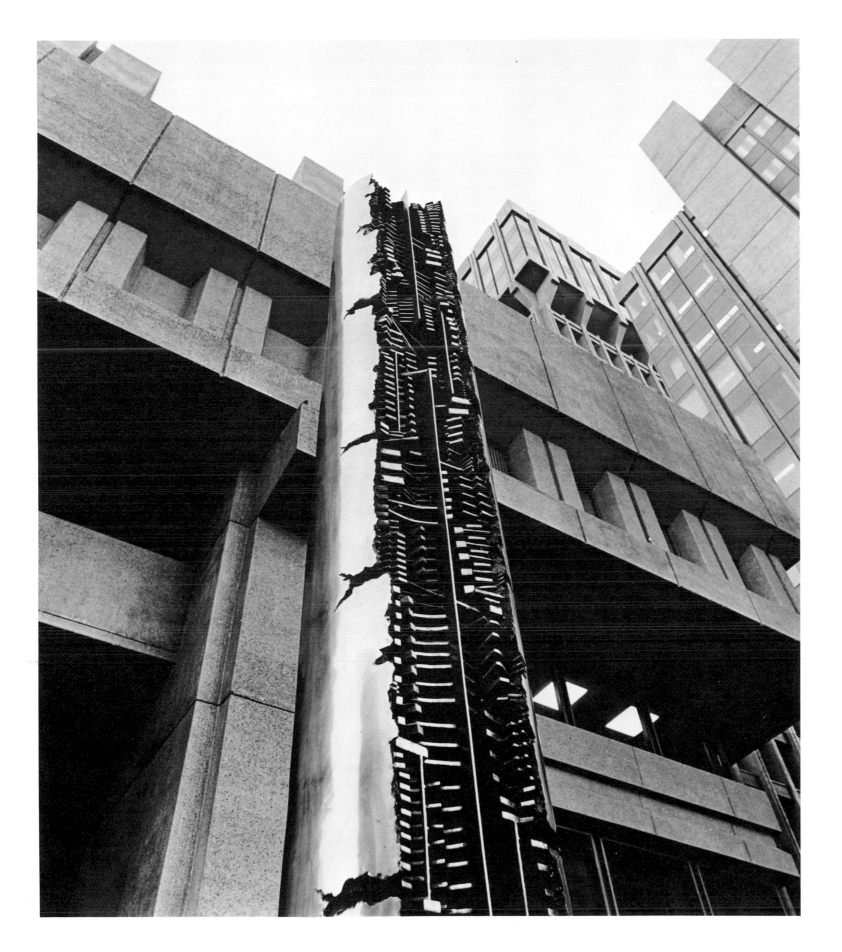

Edward Stasack

Untitled

Concrete. 1968

King Street underpass, Fort Street Mall, Honolulu

Commissioned by the City and County of Honolulu

The transformation of a pedestrian underpass into an agreeable space has been interestingly solved in this example on the Fort Street Mall, at King Street. Opposite a long raised pool with lush planting, Edward Stasack's panels imaginatively depict the forms and historical chronology of the petroglyph, the Hawaiians' ancient form of communication by carved symbols. Cast into concrete, these figures appear as traditionally inscribed on rock faces and lava fields, authentic in scale, with some taken from molds made directly at petroglyph sites. The mural is arranged as a fifty-foot panel, flanked by two ten-foot sections, with chronological progression from the *makai* end of the underpass. In the first panel are simple designs symbolizing birth and life, recorded in the seventh and eighth centuries. The large panel, which contains more sophisticated forms, begins with an overall pattern simulating lava flows as seen from the air along the Kona coast of the island of Hawaii. In addition, rock chips and dust from the King's Highway, with crushed yellow-green olivine found in volcanic *pahoehoe* (smooth lava rock), were sprinkled on the surface of each mold and mingled with earth colors produced by pigments in the concrete. The last panel, at the *mauka* end and shown in the photograph, was produced as part of a "happening," in contrast to the authentic character of the other panels. As the artist's studio was close to a busy street, passersby often stopped to watch the activity. Stasack turned this curiosity to advantage, and observers became participants by inscribing in the mold their own experienced or fantasy impressions of the petroglyph.

Downtown

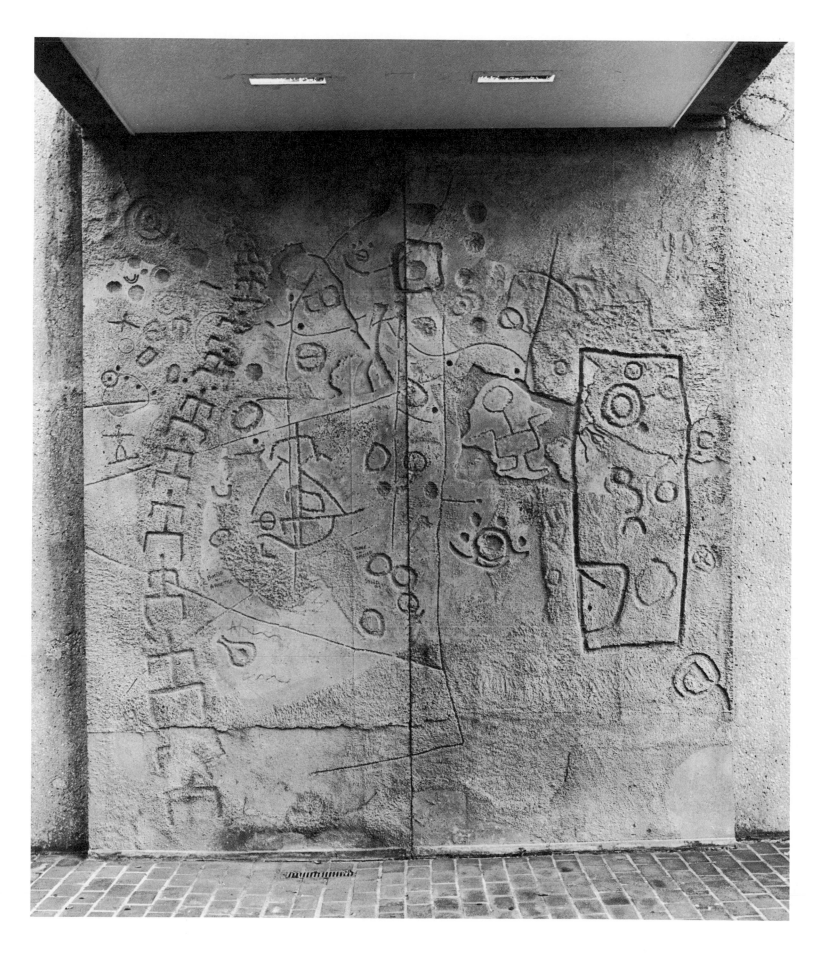

13

Bumpei Akaji

Na Mana Nu Oli

Bronze and copper. 1969

Bishop Trust Company, entrance, King and Bishop streets, Honolulu

Commissioned by Bishop Trust Company

In the climate of Honolulu, fountains are a welcome addition to the cityscape, particularly when successfully integrated with sculpture. In this bronze piece by Akaji, the visual, audio, and tactile experience produced by tumbling water, ingeniously piped through copper "branches" and cascading into a rocky pool is further enriched by the allegory of the hovering *Birds of Glad Tidings*. Local fountain watchers will notice the change in visual effect as the wind velocity and water pressure vary.

Downtown

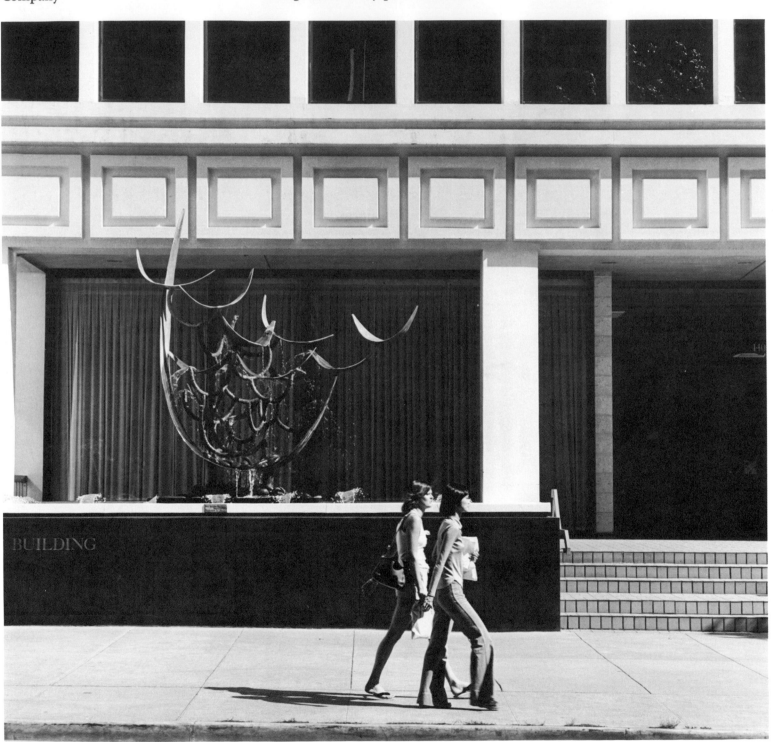

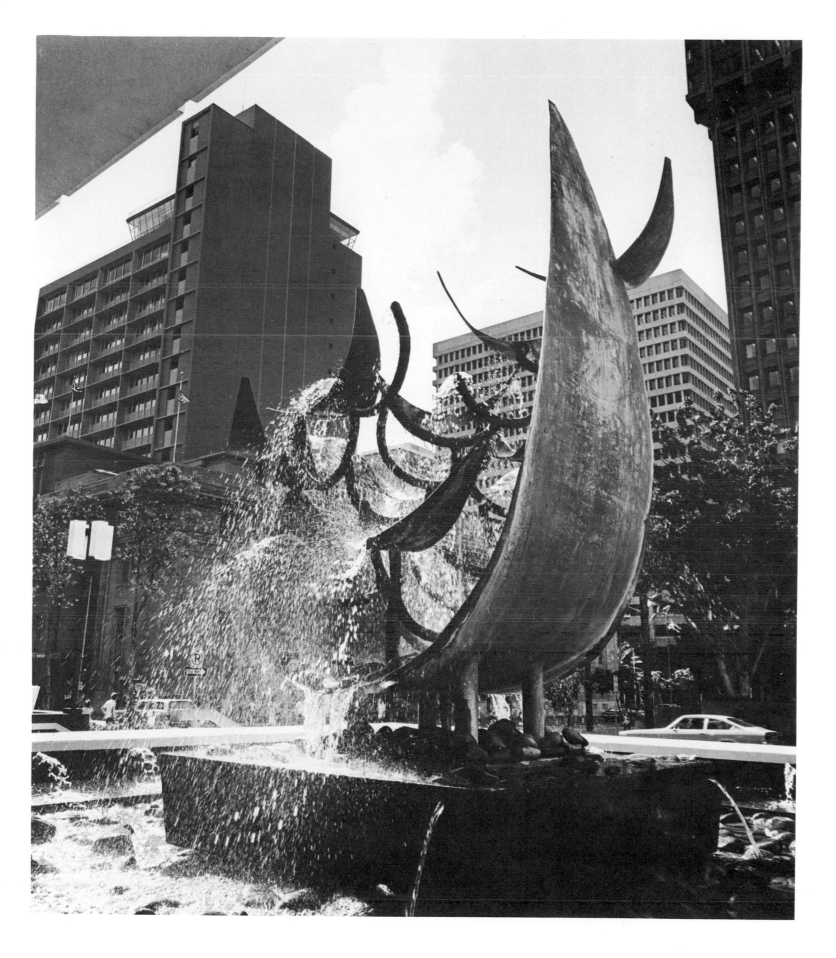

15

Bernard Rosenthal

Kepaakala

Bronze. 1970

Financial Plaza of the Pacific, Bank of
Hawaii, Bishop Street

Commissioned by Financial Plaza of
the Pacific Condominium Owners

Bernard Rosenthal's mirror-finished
bronze sculpture is the brilliant focal
point of the Financial Plaza of the
Pacific, a handsome space on one of
the busiest corners of downtown
Honolulu. A tree-shaded "tidal" pool
and fountain complement the radi-
ance of *Kepaakala,* which means "sun
disk." The sculpture, eleven feet in
diameter, was constructed of a thin,
prepolished bronze skin welded over a
system of armatures. Varying in thick-
ness to four feet, and weighing five
tons, the effect is one of "vault door"
solidity—yet the disk can rotate on its
axis at the whim of passersby, produc-
ing a lively interplay of reflections
against its background of dark bronze
glass.

Downtown

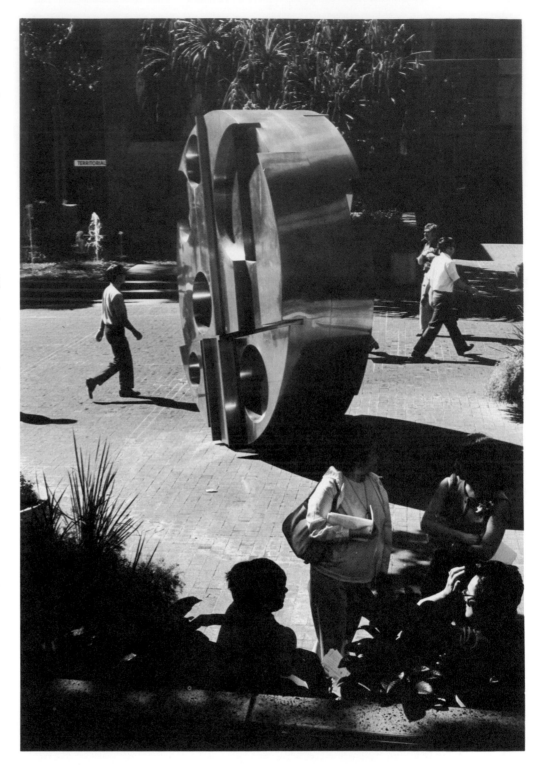

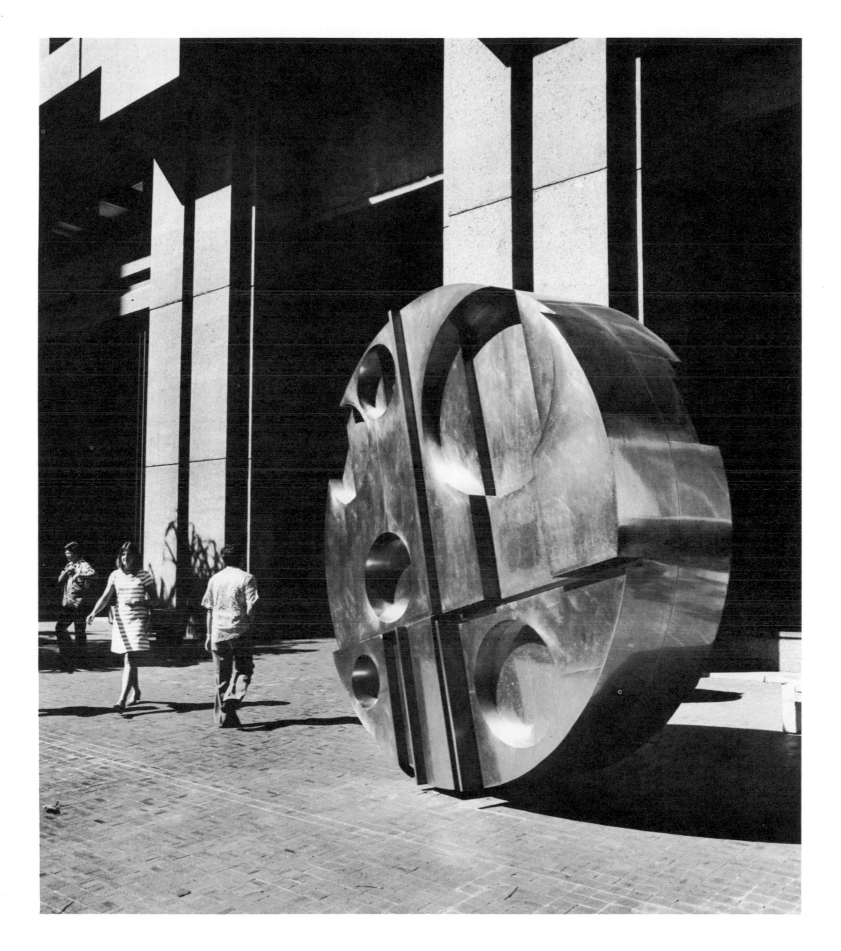

Tom Van Sant

Untitled

Cast concrete. 1971

Davies Pacific Center, 841 Bishop Street and Alakea Street, between Merchant and Queen streets

Commissioned by Theo H. Davies & Company, Ltd.

Three intaglio reliefs of the architectural sculptor, Tom Van Sant, are located on the exterior facades of the Davies Pacific Center and represent the early industries of the Hawaiian Islands during the nineteenth and first part of the twentieth centuries. The panel symbolizing the whaling industry is seen from Bishop Street on the second floor entry to Theo H. Davies & Company. Two panels, of the sugar and cattle industries, are on the Alakea Street side of the building at sidewalk level. The pineapple and shipping industries are represented with two more panels inside the building, completing the series. Installed in 1971, the designs were created in the Los Angeles studio of the sculptor. Molds were carved from polystyrene, and cut in pieces suitable for shipment to Honolulu, where they were reassembled on a large platform. Lifted into place on the building, the concrete was poured by the contractor, Hawaiian Dredging and Construction. After the forms were removed and the murals were sandblasted, Van Sant sharpened up detail directly on the surface, the total process resulting in a crisp, linear style. The reliefs demonstrate the cooperation essential between artist and craftsman in the production of large and technically advanced works of art.

Downtown

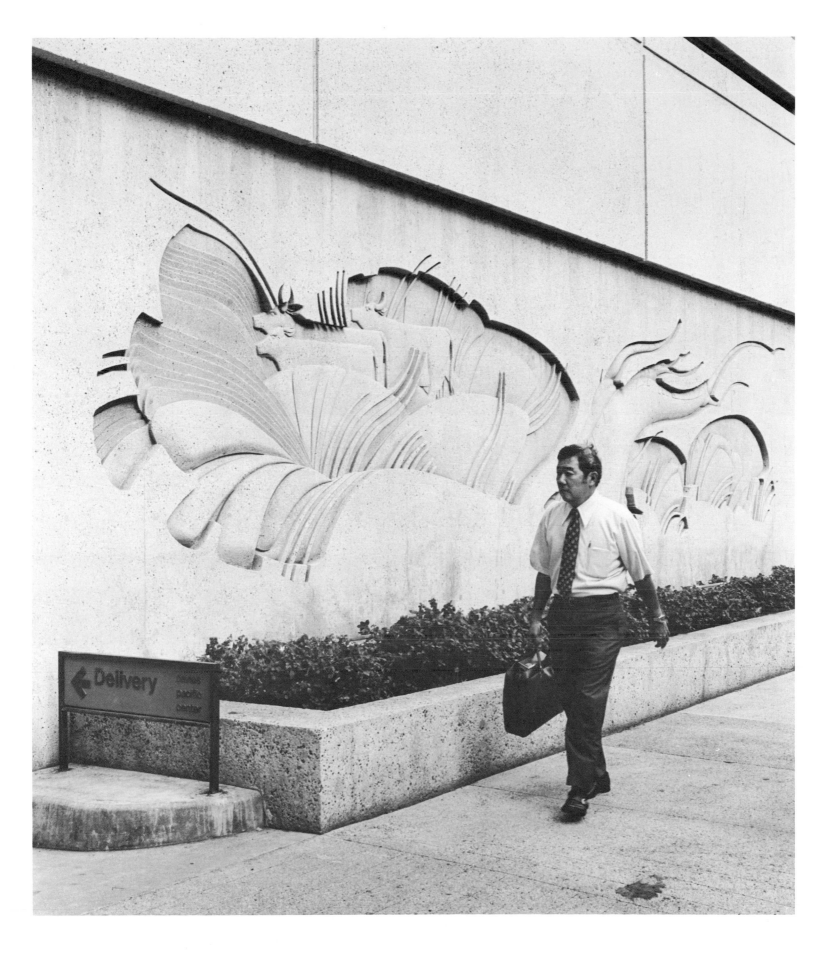

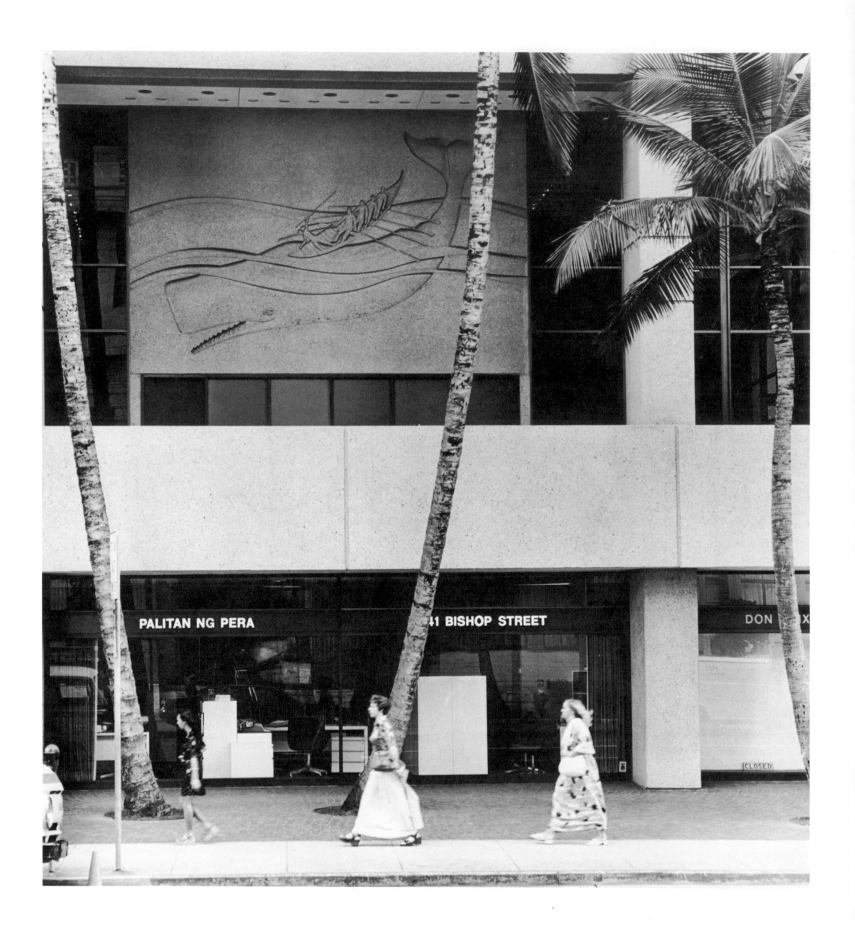

Herb Kawainui Kane

Opening of the Pacific to Man

Wool. 1973

Pacific Trade Center, Alakea and King streets, Honolulu

Commissioned by The Hawaii Corporation

The climate of Hawaii is exploited in this exterior, though covered, installation of a wool mural, a medium traditionally associated with interior spaces. This piece, in a vivid pallet of orange, yellow, and blue, and its companion mural in the mall entrance, *Opening of the Pacific to Trade*, were made by the Sallee Carpet Looms of Santa Monica, California from New Zealand wool which was dyed in Philadelphia. Kane, a recognized authority on Polynesian sailing craft and navigation, has introduced authentic details in his depiction of many ancient sailing craft, including the double-hulled voyaging canoes in which the first navigators reached Hawaii. The figure in the upper right corner represents a stick chart used for navigational training—arrangements of sticks and shells tied together to indicate islands and ocean swell patterns. Kane's designs were scaled up by projector to the eleven-foot by forty-three-foot carpet backing. The wool was then worked by being shot from behind with pressurized tools.

Downtown

Haines Jones Farrell White Gima; Eric Engstrom, Graphic Design

Kilauea Fly Wheel

Restored 1973

Pacific Trade Center Mall, between King and Hotel streets, Honolulu

Commissioned by The Hawaii Corporation

The pedestrian mall between the Pacific Trade Center and the Alexander Young Building, running from King to Hotel streets, provided an opportunity for the installation of this recollection of Hawaii's early sugar technology. The fly wheel, sixteen feet in diameter, is from a Hamilton-Corliss Sugarmill Engine used on Kauai at the Kilauea Plantation from 1906 to 1957. Set on a base planted with sugarcane, it provides a focus at the center of the long, narrow, and pleasantly landscaped mall. With a bright, articulated color scheme and graphic identification of its parts, this historic item becomes an attractive combination of visual excitement and educational interest.

Downtown

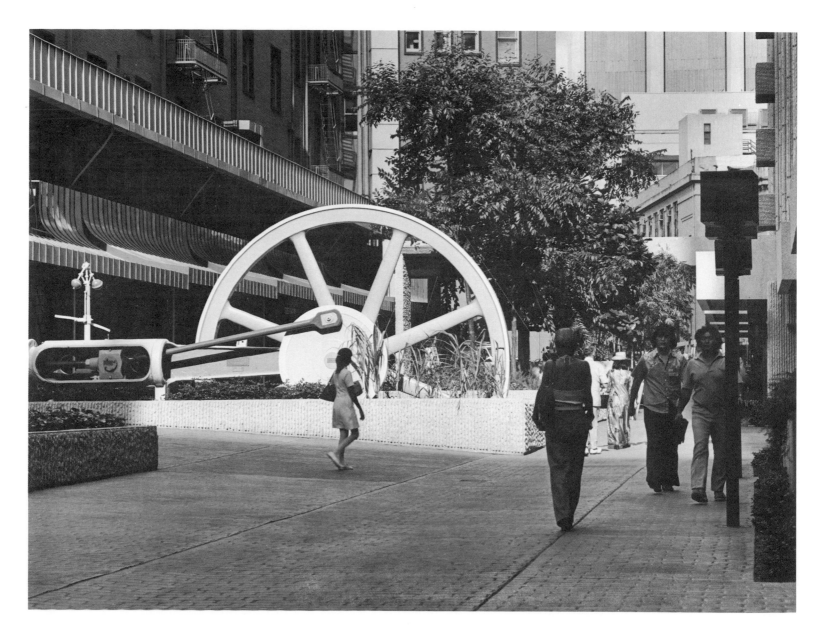

Ivan Mestrovic

St. Andrew

Bronze. 1958

St. Andrew's Cathedral, Queen Emma Square, Honolulu

Donated by Robbins Battell and Mary Morris Anderson and their Children

In recognition of the role of King Kamehameha IV and Queen Emma in establishing the Anglican Church in Hawaii, early plans to name the new Cathedral after St. Peter were changed. The untimely death of the king occurred on St. Andrew's Day, and in remembrance of this event the name of the cathedral was selected. In 1958, ninety-one years after the cornerstone was laid, the consecration of the final additions of the cathedral took place, with the new fountain and its sculpture of *St. Andrew* located prominently in the close. The ten-foot bronze sculpture of the Gallilean Fisherman with strong hands and sensitive features stands appropriately in a long rectangular pool, flanked by olive trees. The light-catching quality of the highly modelled surface of the work is emphasized by the lively play of sun and water jets from spouting bronze fish by the French sculptor, Robert Laurent. Mestrovic was one of Yugoslavia's most famous sculptors. While living in the United States, his main patron was the Church, accounting for the preponderance of religious sculpture he produced during the last sixteen years of his life.

Downtown

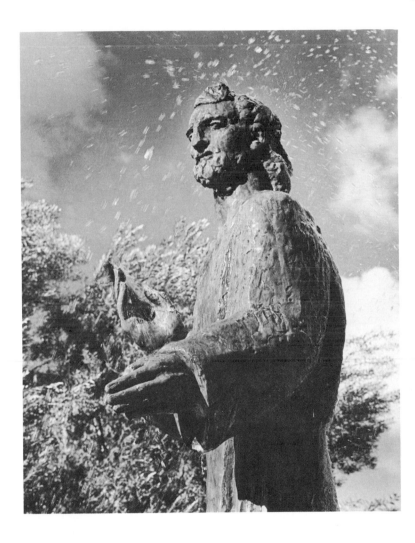
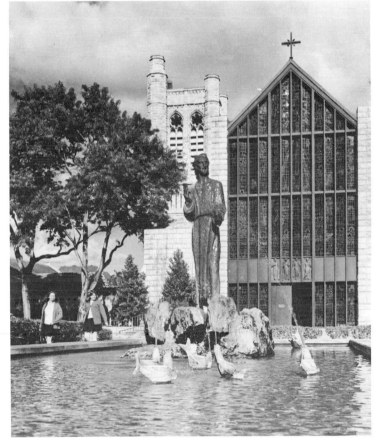

Bumpei Akaji

The Eternal Flame

Copper. 1974

Hawaii State Capitol Mall, *mauka* of Beretania Street, Honolulu

Commissioned by The Pacific War Memorial Commission

Sculpture funded by the State Foundation on Culture and the Arts

The focus of the memorial dedicated to the men and women of Hawaii's armed forces, Bumpei Akaji's sculpture is placed at the end of a mall which is the *mauka* extension of the State Capitol complex. The setting is symmetrical and serene, its backdrop a distant view of Punchbowl. The somber, curvilinear planes of the sculpture, reminiscent of armor and the brutality of war, thrust upward, forming a protected bowl for the symbolic eternal flame. Though the work appears to be massive, its light structure is well expressed by the brazing of the copper plates along the concealed ribs of its supporting framework.

Downtown

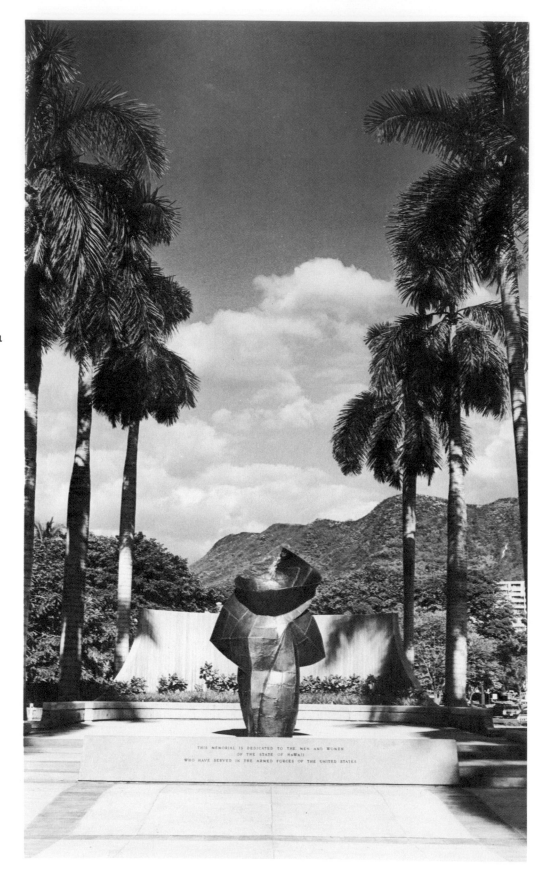

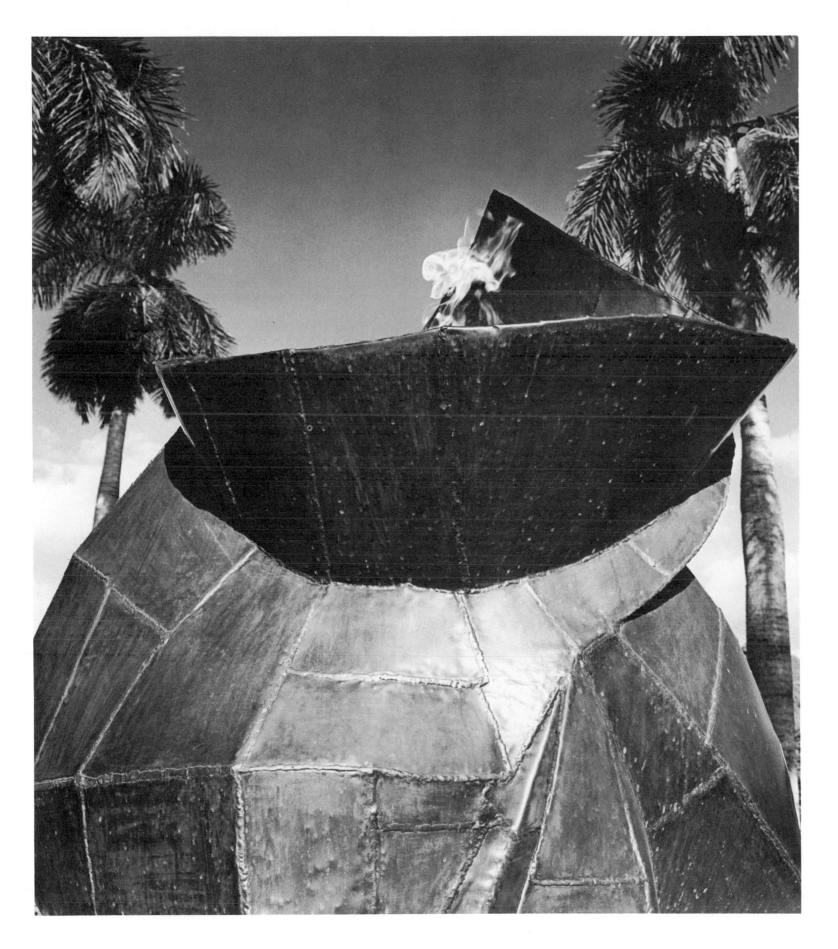

Marisol

Father Damien

Bronze. 1969

Hawaii State Capitol, Beretania and Punchbowl streets, Honolulu

Commissioned by the State of Hawaii Statuary Hall Commission

In 1967, the state legislature selected the Reverend Joseph Damien De Veuster, along with King Kamehameha, as one of the two citizens of Hawaii most worthy of commemoration in the National Statuary Hall in Washington, D.C. The result was this poignant interpretation by the Venezuelan-born American sculptress, Marisol, of the priest who for sixteen years ministered to the lepers and died among them on the island of Molokai. The larger-than-life bronze figure, first carved in wood, retains some of the textural characteristics of the original medium. In its plain solidity, typical of Marisol's style, it seems to symbolize the resolute qualities of

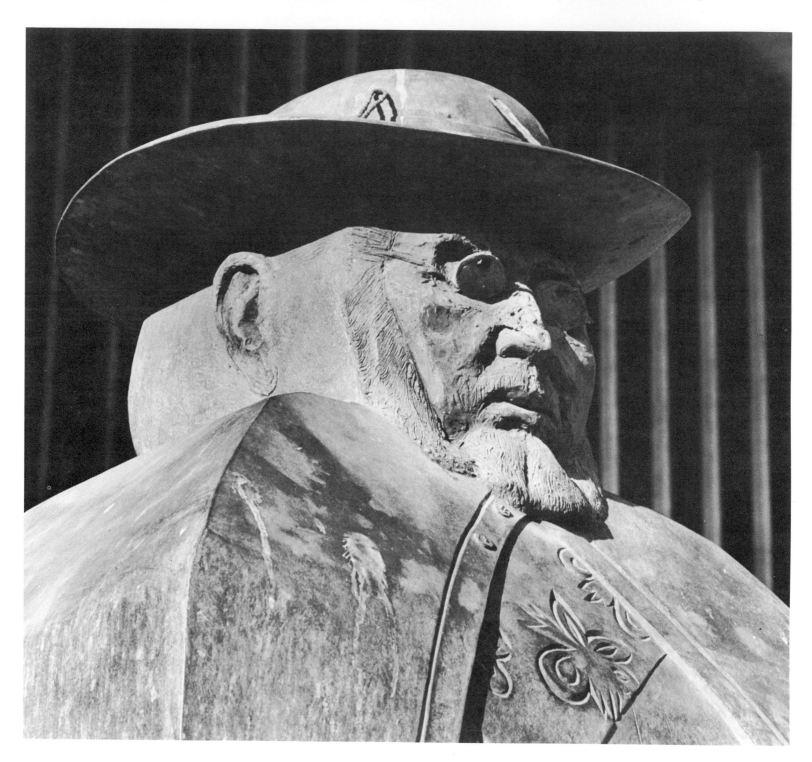

Father Damien. Using only sparse detail, the simplified concept further emphasizes the rough texture of the face, evidence of the disease which caused his death. An arm sling, with decorative detail of a Hawaiian fabric, is visible under his cloak, indicating the advanced stage of his illness. This twin cast, now located under the lofty portico of the State Capitol, faces in complementary dignity the solemn *Eternal Flame* of Akaji across Beretania Street.

Downtown

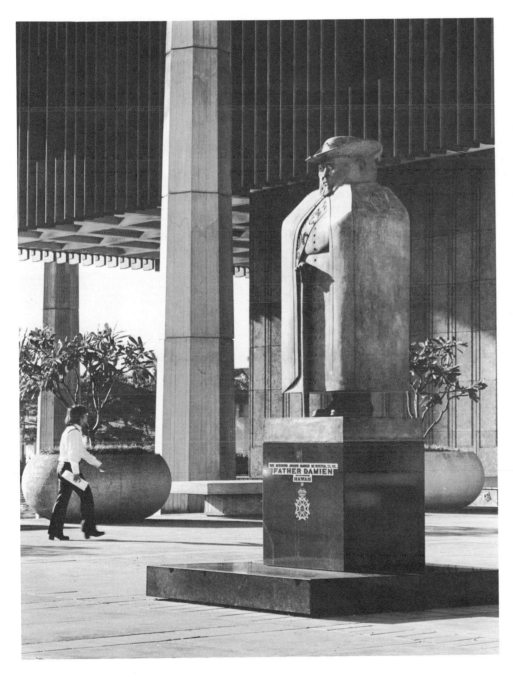

Tadashi Sato

Aquarius

Mosaic. 1970

Hawaii State Capitol, Beretania and Punchbowl streets, Honolulu

Commissioned by the State Comptroller

Hundreds of thousands of Italian glass tiles were used by Sato in the mosaic *Aquarius,* located in the center of the great open court of the Hawaii State Capitol. Best viewed from the balcony of one of the upper floors, the circle, thirty-five feet in diameter, is composed of overlapping and superimposed irregular ellipses. In the shades of blue and green familiar to the ocean waters of Hawaii, the design suggests the movement of dappled light and underwater formations. After rain showers, the surface becomes a shimmering reflective pool.

Downtown

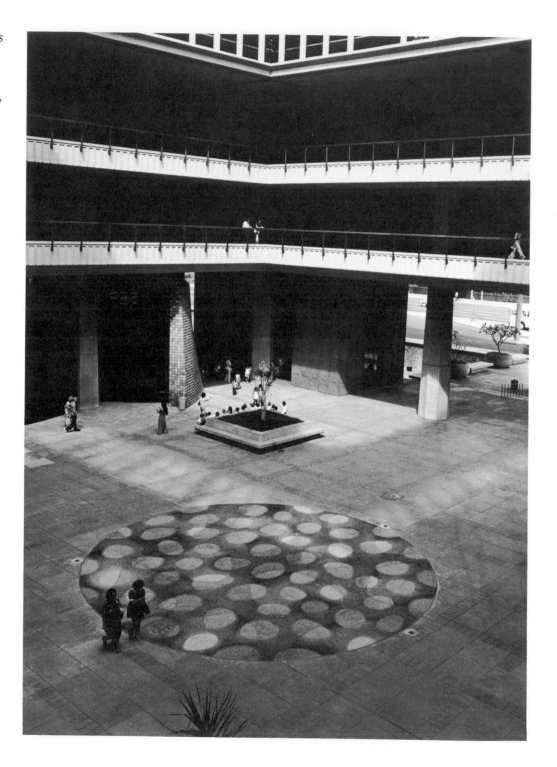

Barbara Hepworth

Parent I and *Young Girl*

Bronze. 1970

Hawaii State Library, Mauka Sculpture Garden, 478 South King Street, Honolulu

Purchased by the State Foundation on Culture and the Arts, 1973

These two works face each other in kinship, for they are of the "Family of Man," a series of nine bronzes by the internationally famous British sculptress, Dame Barbara Hepworth. The space, and the sculptures' placement within it, defines their relationship—*Young Girl* within the circle and the nine-foot *Parent I* slightly outside and aloof. The larger sculpture, bold in form and complexity, and *Young Girl,* contained and more subdued, both share the beauty of the subtle textures and blue-green coloring of the bronze surfaces. Space that penetrates form, a characteristic of Hepworth, works in different ways in these two works—dynamically, by the funnel opening of *Parent I,* and quietly, through the narrow opening

of the smaller sculpture. The pair are placed among landscaped mounds of *hemigraphis* and *agapanthus*, designed by Walters, Kimura and Associates, on a lawn between the State Library and the Capitol building. Created in 1970, the "Family of Man" series is limited to six casts of each piece.

Downtown

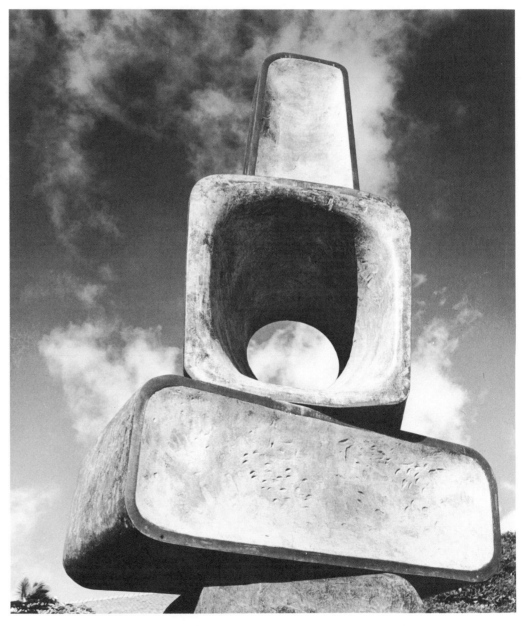

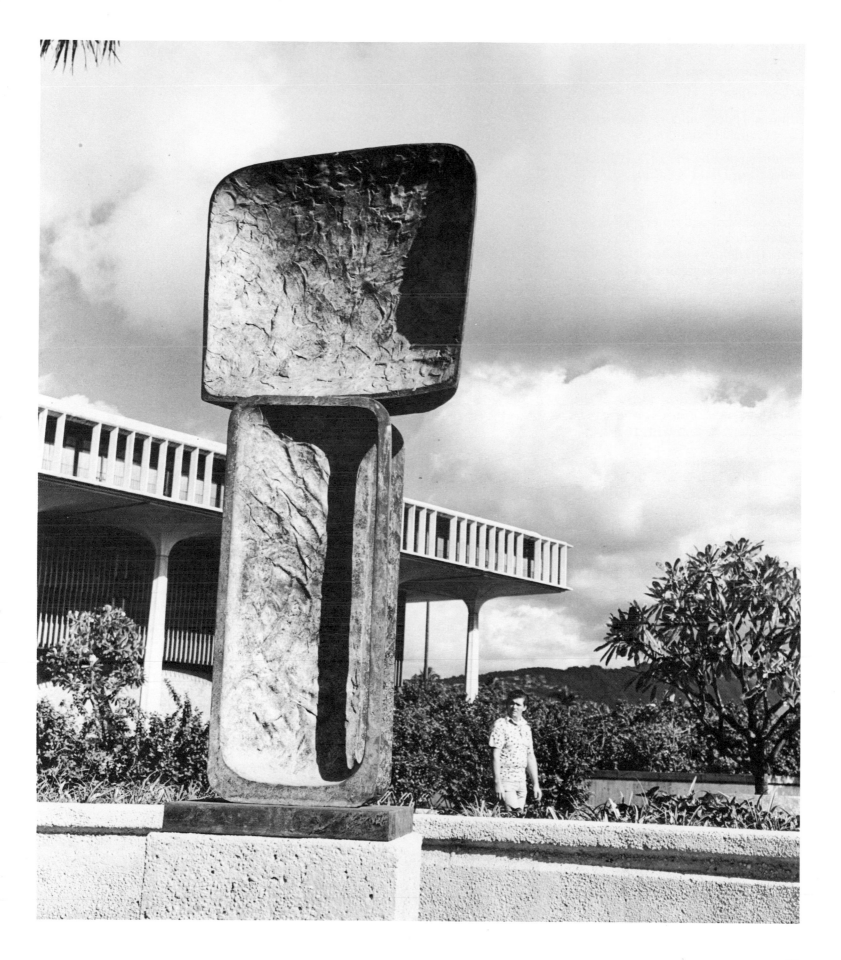

Thomas Ridgeway Gould

King Kamehameha I

Bronze. 1883

Aliiolani Hale (Judiciary Building),
Civic Center, Honolulu

Commissioned by the 1878 Legislature
under King David Kalakaua

Three identical sculptures now exist of
Hawaii's first great king, Kameha-
meha I. The first, proposed to com-
memorate the centennial of Captain
Cook's "discovery" of the Hawaiian
Islands, was modeled in Florence by
Boston sculptor Thomas Gould and
cast in Paris. This statue, lost at sea in
1880 and subsequently recovered after
the completion of a replacement cast
from the original mold, now stands in
Kapaau, in the Kohala district of the
island of Hawaii, birthplace of the
warrior king. Illustrated here is the
second cast, with four bronze plaques
depicting incidents in the life of King
Kamehameha, dedicated in 1883 in
front of the Aliiolani Hale during
the coronation ceremonies of King
Kalakaua. Though it is not a portrait
statue, Gould worked from sketches,
and his version of Kamehameha, in
dark bronze and gilt, is idealized,
showing him in robes of state and
battle. Annually, on Kamehameha
Day, the king's statue is affectionately
festooned with birthday leis. The
third cast, from a new mold made
from the Honolulu statue in 1969,
stands, along with Marisol's sculpture
of Father Damien, in the National
Statuary Hall in Washington, D.C.

Downtown

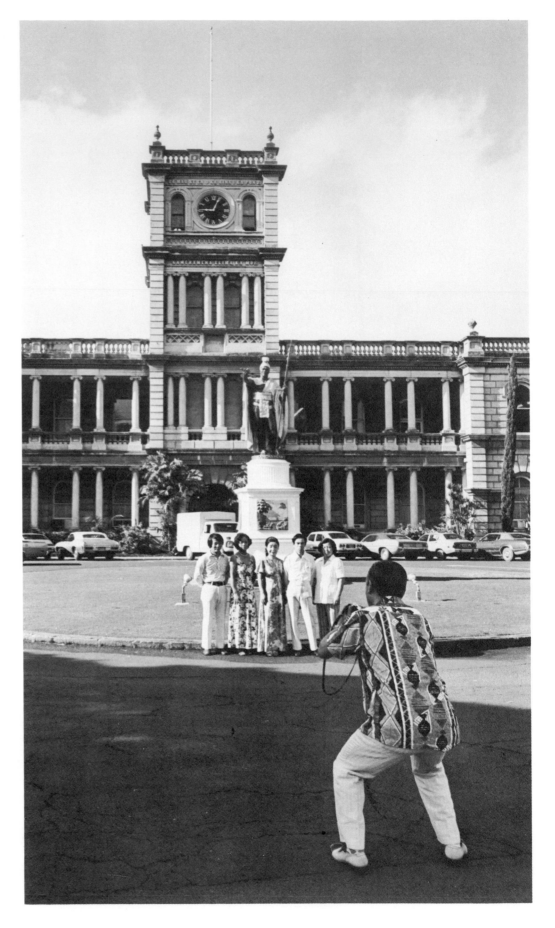

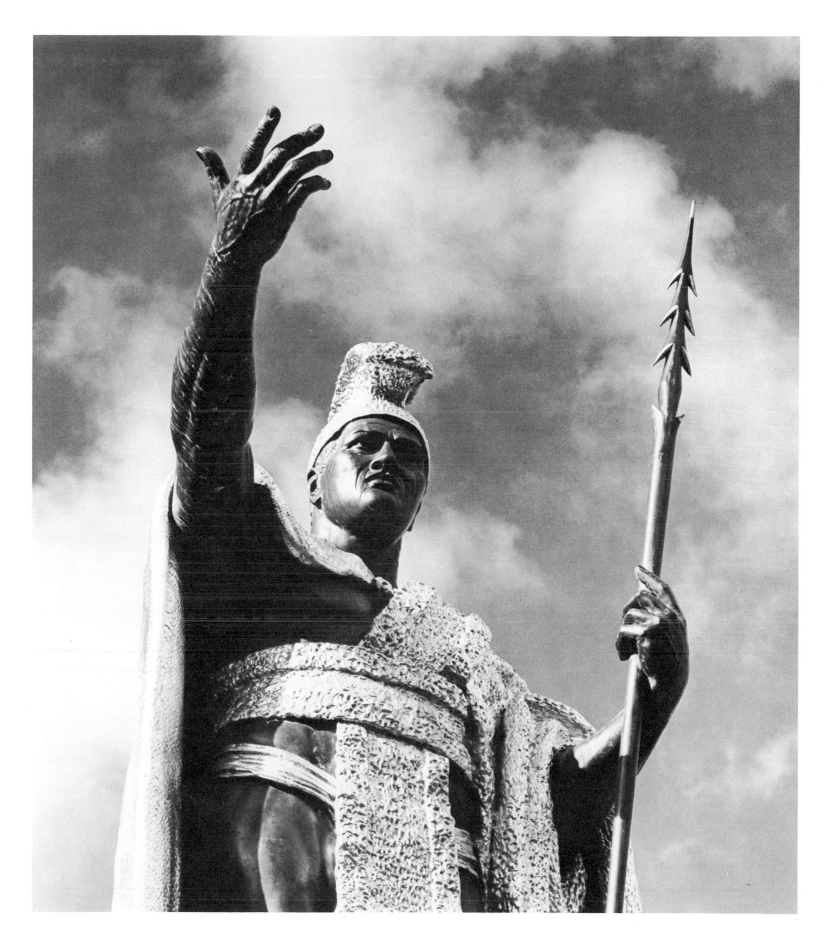

Anonymous

Hiroshima Monument

Granite. 1960

Foster Botanic Garden, 180 North
Vineyard Boulevard, Honolulu

Gift of Hiroshima Prefecture of Japan
and the City of Hiroshima to the City
of Honolulu

Surrounded by *mussaenda* and butter-
cup trees, near the Nuuanu end of the
Foster Botanic Garden, this ruggedly
carved monument commemorates the
seventy-fifth anniversary of the first
Japanese immigrants to arrive in
Hawaii. The ''C'' form, symbolic of
''century,'' represents seventy-five
years when notched. Four old Chinese
characters on the sides of the sup-
porting pillar signify that ''blessings
from heaven are invoked by peace and
harmony.'' Quarried in the vicinity of
Hiroshima and carved in Japan by
local artists, it is one of the few large
granite sculptures in Hawaii. School
children may often be found examin-
ing this sculpture and the nearby
bronze replica of the Great Buddha
of Kamakura, contrasting monuments
to similar events.

Nuuanu

Eli R. Marozzi

Natana

Cast stone. 1958

Tennent Art Foundation Gallery, entrance court, 203 Prospect Street, Honolulu

Commissioned by Madge Tennent for the Foundation

The strongly modeled figures of Marozzi's bas-relief, when caught in the bright sunlight, seem to emerge dancing from their framed panels, whose shallow depth belies the powerful sculptural quality of the work. The stylized figures, in the tradition of the rhythmic flow of the classical frieze, express the movement of the Indian dance referred to in the Sanskrit title, *Natana*. The approach to the gallery is particularly enjoyable, proceeding across the lawn, under the Java olive tree, and descending a stair into the intimate court, passing several small Marozzi sculptures beside the steps. The six-foot by nine-foot relief, of cast white marble aggregate, is mounted on a white masonry wall opposite the doors to the gallery, the total space enhanced by the contrast of the lush, dark green foliage.

Punchbowl

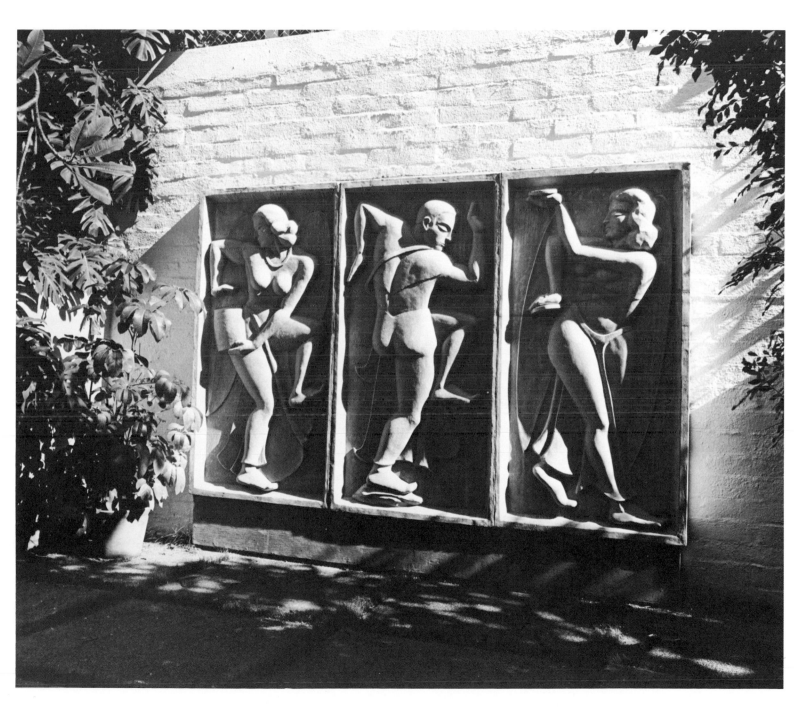

Emile Antoine Bourdelle

La Grande Penelope

Bronze. Original dated 1912, Cast #4–1956

Honolulu Academy of Arts, 900 South Beretania Street, Honolulu

A gift in memory of Mrs. Richard A. Cooke by her children, 1965 (3334.1)

Approaching the entrance of the handsome Honolulu Academy of Arts, designed by the architect Bertram Goodhue, *La Grande Penelope* can be seen at some distance before entering the main gates. Framed in a white masonry niche three times its height, the eight-foot bronze sculpture is the focus of the main central court of the academy. The French sculptor Bourdelle was for many years a chief assistant to the great Rodin. Though influenced by his master, considered the father of modern sculpture, Bourdelle in his treatment of *Penelope* shows his strong ties to the nineteenth century, with its interest in classic styles and themes. Here he deals with the story of the wife of King Odysseus and her long wait for his return from the Trojan Wars. Her faithfulness and patience were eventually rewarded by his safe return to Ithaca. Pensive in attitude and quiet in mood, the figure is lent a sense of constrained movement by the thrust of the hip and the graceful counterpoised "S" curves. To appreciate the monumentality of the sculpture and its weathered patina, one must approach it at the platform level. Bourdelle made studies of *Penelope* for a number of years, and this cast number four of the 1912 version was executed posthumously in a Swiss foundry in 1956, under the supervision of Madam Cleopatra Bourdelle.

Thomas Square

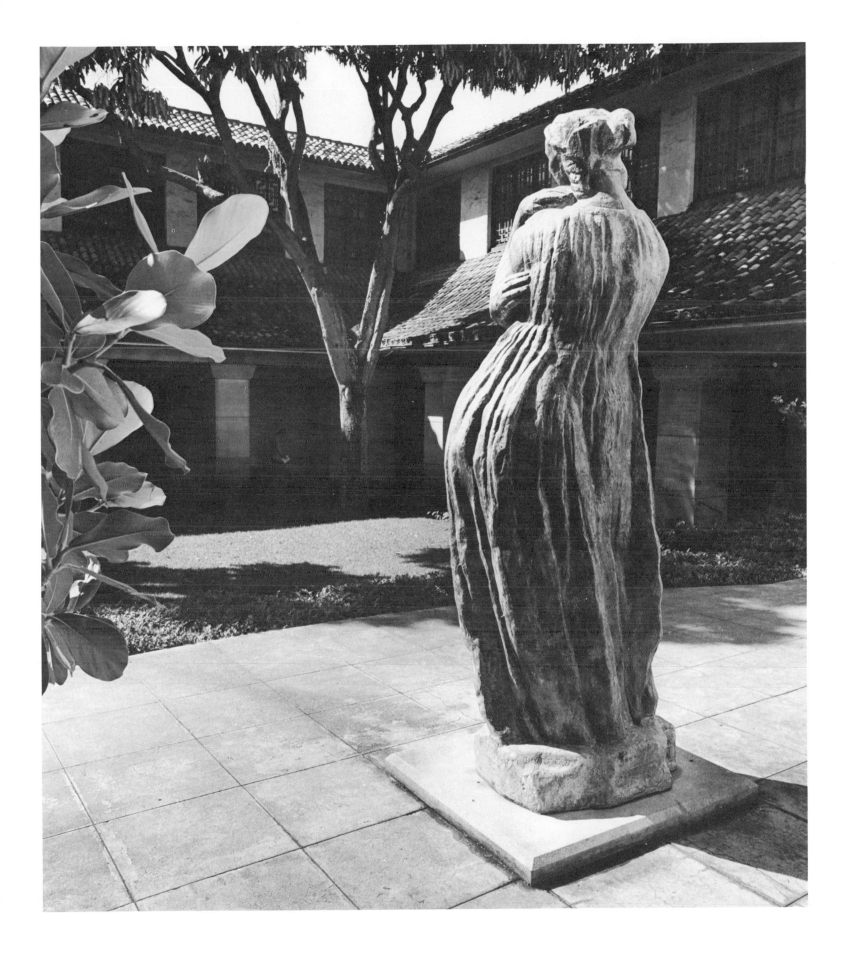

Jacques Lipchitz

Mother and Child

Bronze. 1930

Honolulu Academy of Arts, 900
South Beretania Street, Honolulu

Purchased 1970 (3699.1)

The oriental serenity and symmetry of
the Kinau court of the Honolulu
Academy of Arts provides a calm set-
ting for this powerfully articulated
work of the Lithuanian-born American
sculptor, Jacques Lipchitz. The scale
of the court is ideal for this small,
fifty-six-inch high sculpture. Through-
out his lifetime, Lipchitz was obsessed
with the theme of the mother and
child, and created many versions in
many different styles. Though *Mother
and Child* has cubist characteristics
evident in the angular planes of the
faces, in 1930, when the sculpture
was completed, Lipchitz was already
turning away from the movement in
which he played a major role. In this
work the bulging curvilinear forms of
the figures and their dynamic organi-
zation express the primitive theme
with great intensity. This sculpture is
number six of seven casts.

Thomas Square

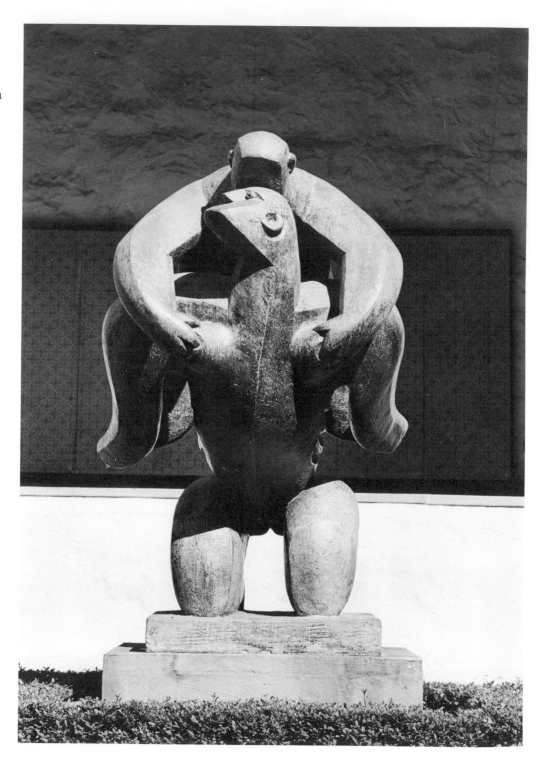

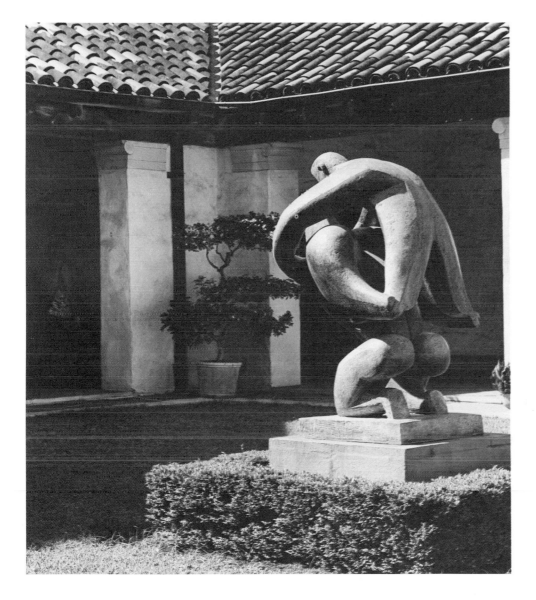

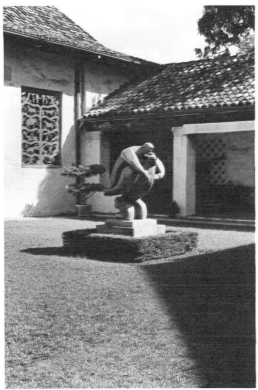

Marguerite Blasingame

Untitled

Marble. 1935

Lester McCoy Pavilion, Ala Moana
Park, Honolulu

The "old" pavilion in Ala Moana Park, a semi-enclosed structure built in the mid-thirties as part of the Ala Moana Park project, now slightly modified, is incorporated into the handsome new Lester McCoy Pavilion complex. The visual opulence of the large central court, part of the original scheme, might cause one to overlook a pair of marble bas-reliefs set into walls at either end of the old pavilion. In contrast to the bold curves of the pools and walls, with their volutes and classical motifs, the reliefs are a quiet statement of decorative design. The stylized panels, consisting each of a pair of figures, are chiseled in elegant, rhythmic, curvilinear patterns, typical of much art of the thirties. The panel on the *mauka* side depicts figures playing Polynesian nose flutes.

Ala Moana

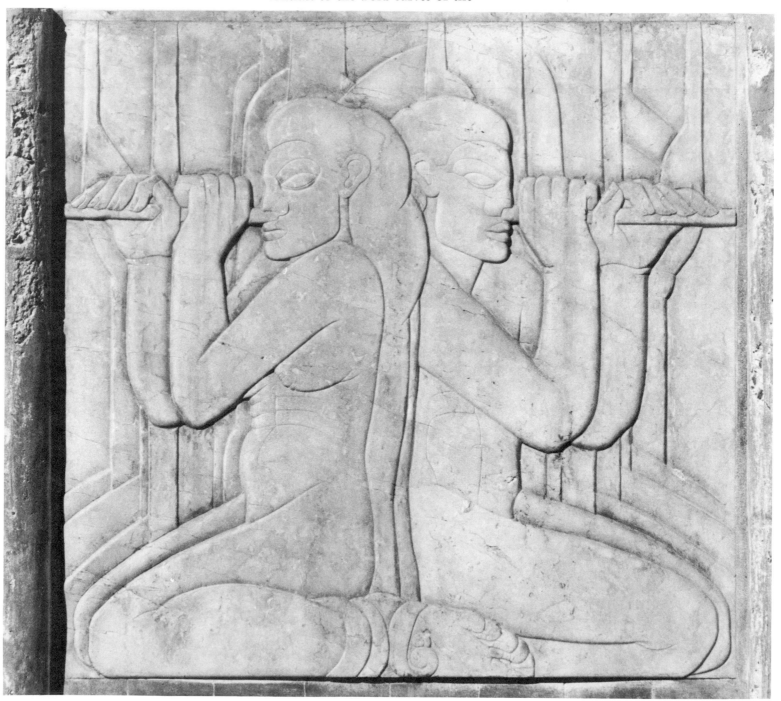

Charles J. W. Chamberland, A.I.A.

Untitled

Terrazzo, copper. 1975

Lester McCoy Pavilion, Ala Moana Park, Honolulu

Commissioned by the City and County of Honolulu, Department of Parks and Recreation from funds donated to the city by Hazel McCoy

The form of the hip roof of Charles Chamberlain's distinguished new McCoy Pavilion is subtly echoed in the fountain which was designed for the small adjacent court. Rising from a shallow pool, an eccentric pyramid is surmounted by a small reverse pyramid forming the upper fountain basin. Water spilling to the apex basin, then flowing over the sides of dark basaltic rustic terrazzo in narrow troughs, produces an inescapable allusion to the volcanic origins of Hawaii.

The court and fountain are handsomely illuminated at night.

Ala Moana

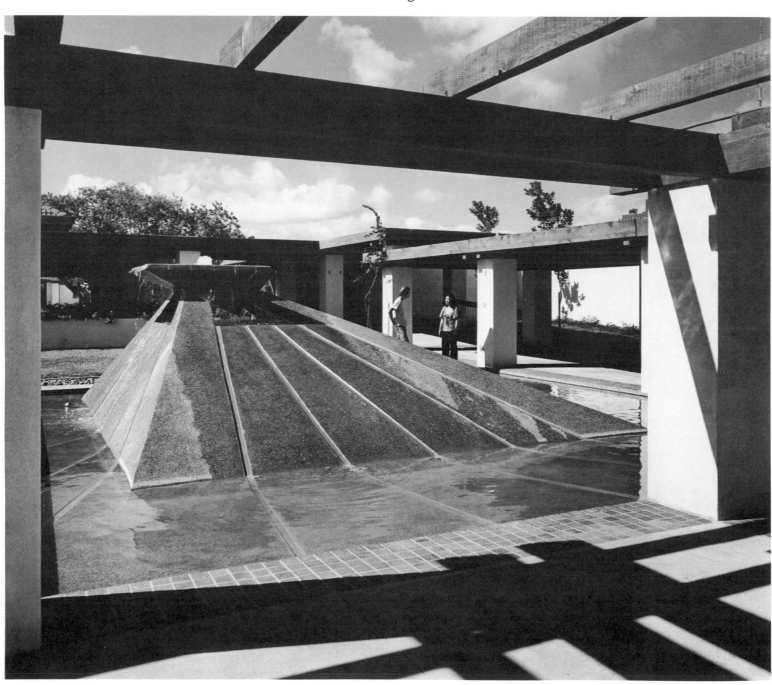

George Tsutakawa

Waiola

Bronze. 1966

Ala Moana Center, 1450 Ala Moana Boulevard, Honolulu

Commissioned by Dillingham Corporation

Shoppers suddenly become aware of the roar of water as they near the Diamond Head end of the Ala Moana Center Mall. Located in a two-story open court, Tsutakawa's impressive fifteen-foot sculpture-fountain cascades over one thousand gallons of water per minute in nine separate waterfalls from delicately balanced lanternlike forms. Also reminiscent of rock cairns, they are a theme used by Tsutakawa in other works. This sculpture, whose Hawaiian name means "living waters," was fabricated of welded bronze plates and is supported by its handmade water conduits. The dark patina, with a wax finish, was achieved by "aging" the metal with chemicals.

Ala Moana

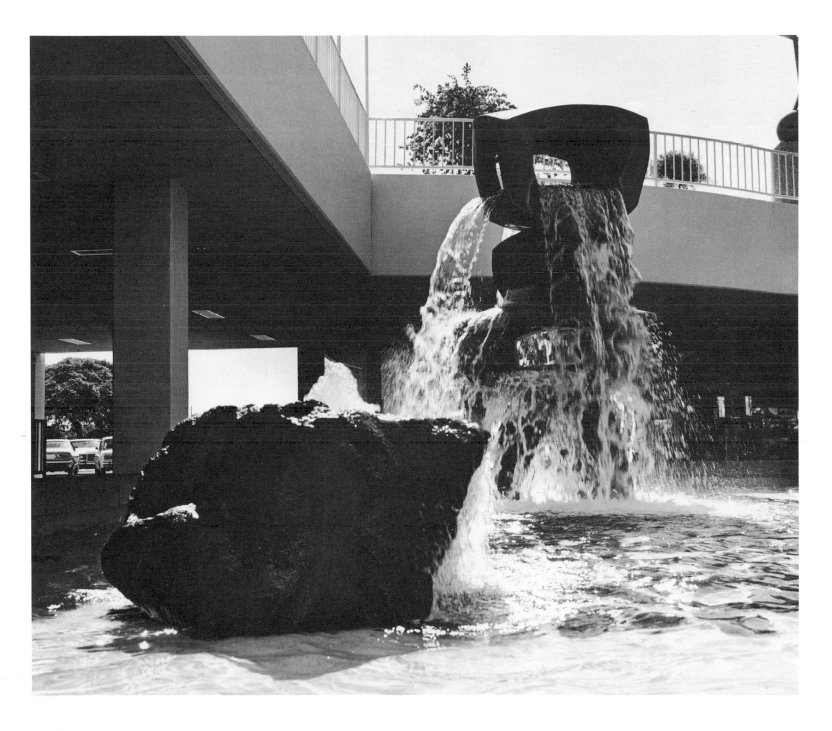

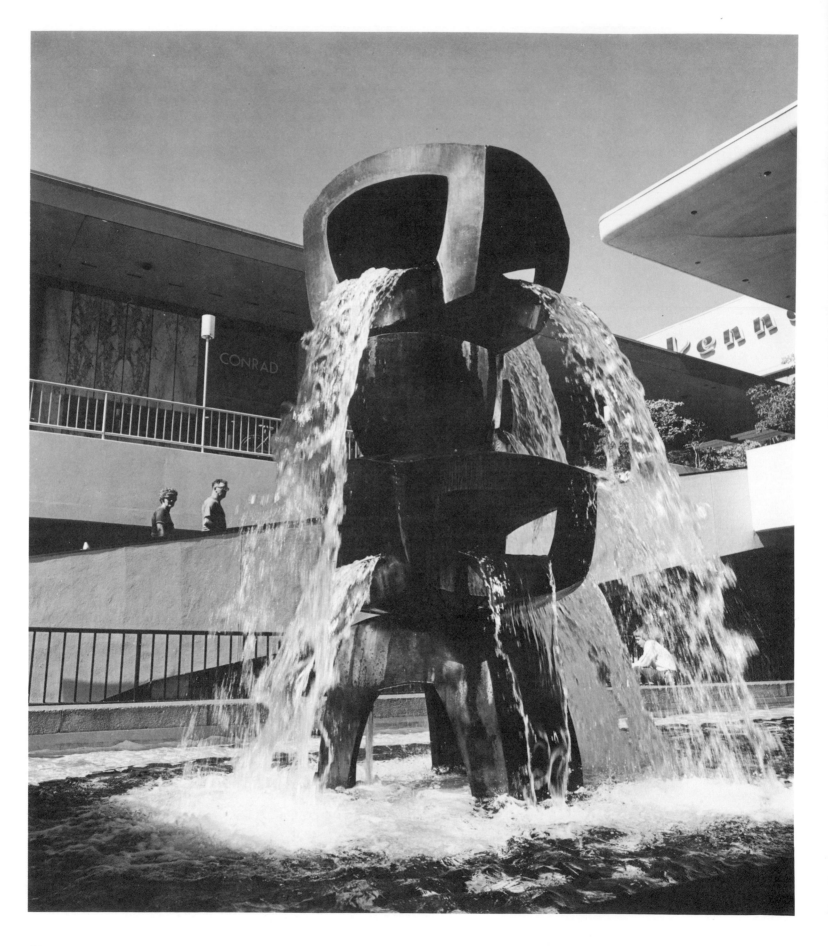

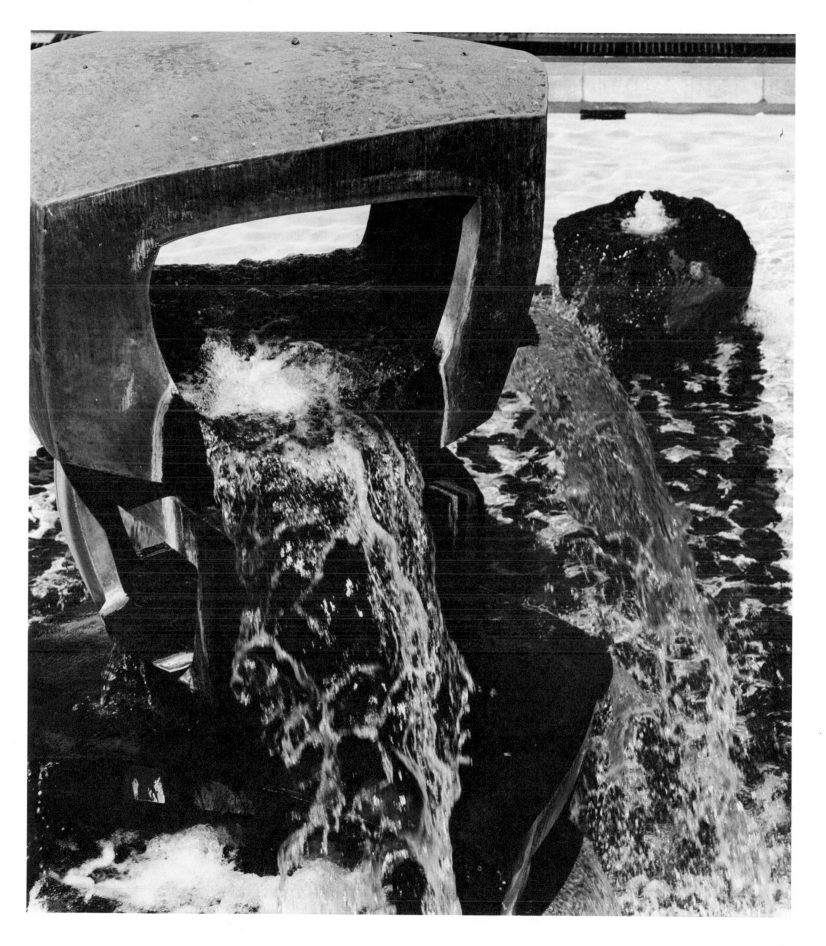

Hon-Chew Hee

Hawaiian Holiday

Concrete. 1962

Hawaiian Holiday Apartments, 1420
Wilder Avenue, Honolulu

Commissioned by Hawaiian Holiday
Incorporated, Ltd.

Hawaii artist Hon-Chew Hee built the
form and cast this three-story concrete
mural in his backyard with the
assistance of a few helpers. Using a
color-coded template, he built up
figures of wood laminations, varying
in thickness from one-and-one-half to
one-fourth inches and cut with an
electric handsaw. After pouring, the
varying recesses of the intaglio pro-
duce a wide range of shadow—a rich
effect which varies with the time of
day. It's a South Sea fantasy of playful
figures, musicians, hula dancers, and
pigs all cavorting under a spreading
breadfruit tree. The overall abstract
quality of the composition is par-
ticularly appropriate to its function as
a decorative building facade.

Makiki

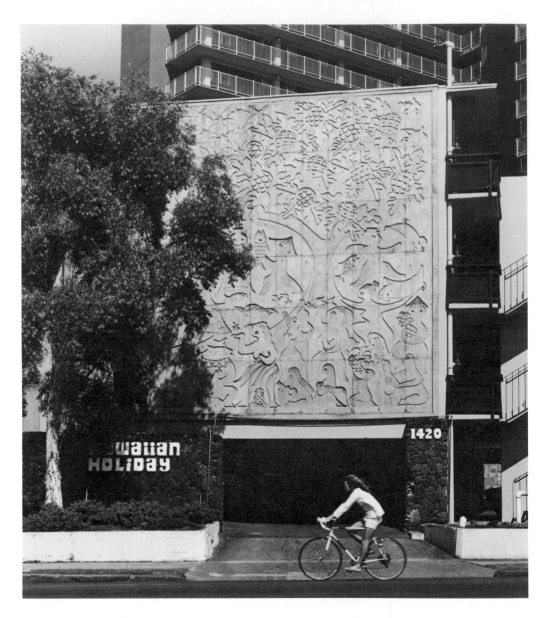

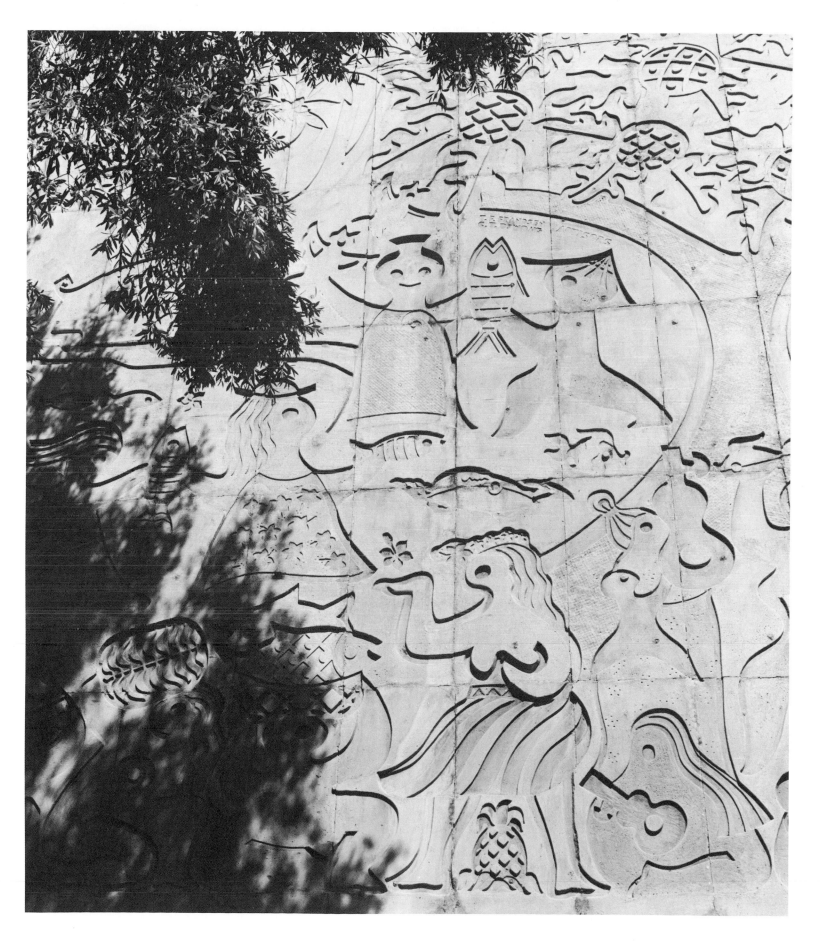

Alexander Liberman

Gate of Hope

Steel. 1972

Holmes Hall, University of Hawaii,
Manoa Campus

Commissioned by the State
Foundation on Culture and the Arts

Alexander Liberman's monumental sculpture relates well in scale and character to the precise forms and primary color accents of the engineering building and its dark background of the Koolaus. Thirty feet high, painted red with an industrial epoxy finish frequently used by Liberman, this piece was fabricated of three-eighths–inch steel plates, cut, rolled, and welded by the Hawaiian Welding Company, Ltd. Giving an impression of extraordinary lightness for its size and weight, the formal aspect of this dynamic work varies rapidly with the observer's viewpoint.

Manoa

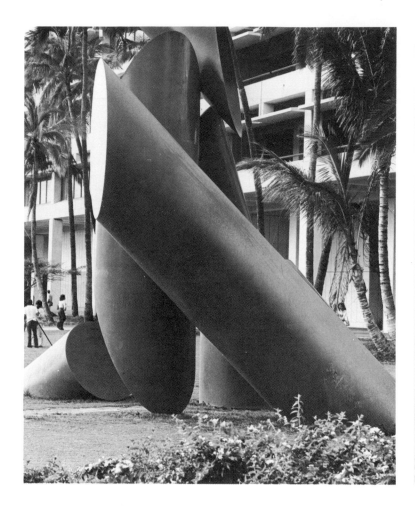
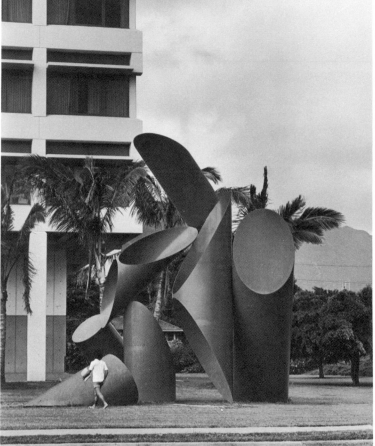

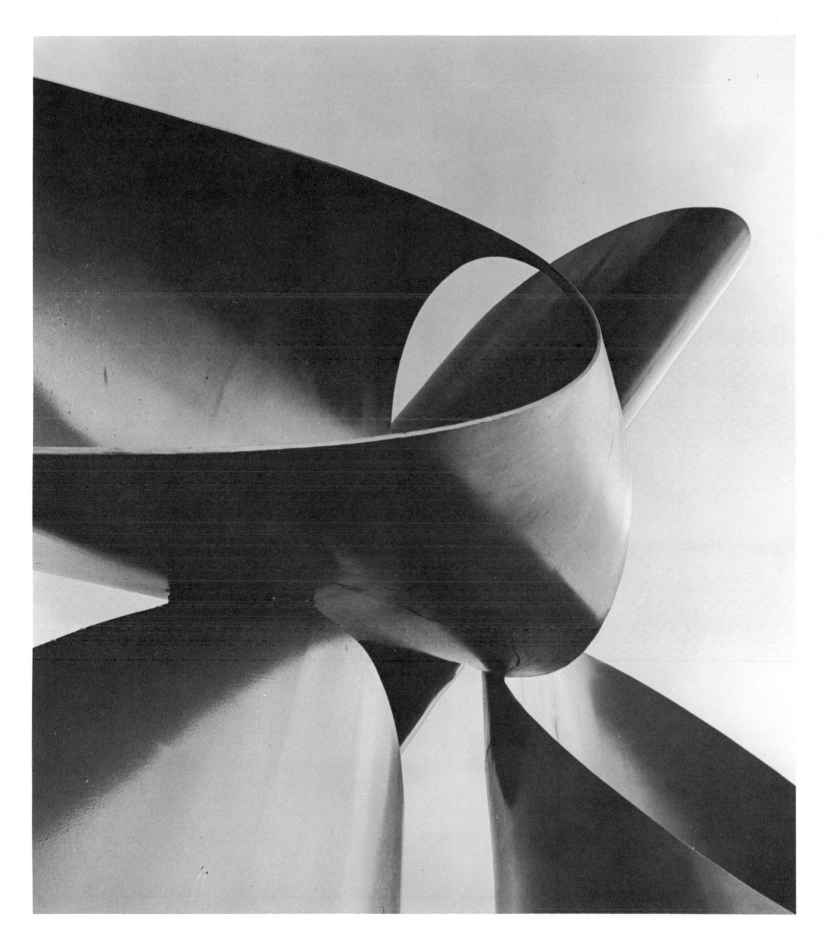

Bruce Hopper

Krypton : 1 x 6 x 18

Steel. 1973

Watanabe Hall, University of Hawaii, Manoa Campus

Commissioned by the State Foundation on Culture and the Arts

A dark slab, recalling the monolith of *2001: A Space Odyssey,* has been "resting," appropriately in front of a science building, since its mysterious descent in 1973. The sculpture, one foot deep by six feet wide and standing eighteen feet high, was constructed of steel. The surface, finished with chemical washes, has acquired a patina of dark grey and green. Completing the illusionary effect, this rare example of "audible" sculpture emits a programmed, low-decibel hum from a vibrating speaker.

Manoa

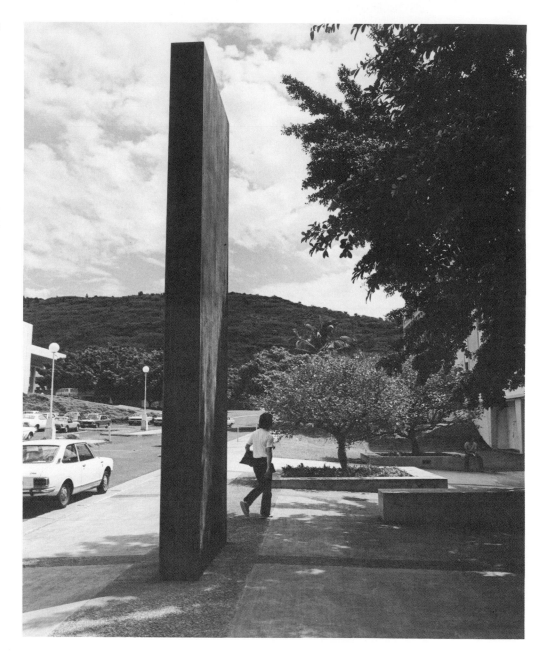

Charles Higa

Alchemy

Ceramic. 1972

Bilger Hall Annex, University of Hawaii, Manoa Campus

Commissioned by the State Foundation on Culture and the Arts

Since the ceramic process is a chemical one—transforming earth and water by fire—Charles Higa's screen, *Alchemy,* is an appropriate concept for the chemistry building annex. Designed as a visual relief from the severity of the entrance, its patterns and wash effects in blues and greens flow gracefully over undulating forms. Built up by the coil method, the textured stoneware shell was fired in sections. Standard commercial glazes were used, with the addition of ash for special color effects.

Manoa

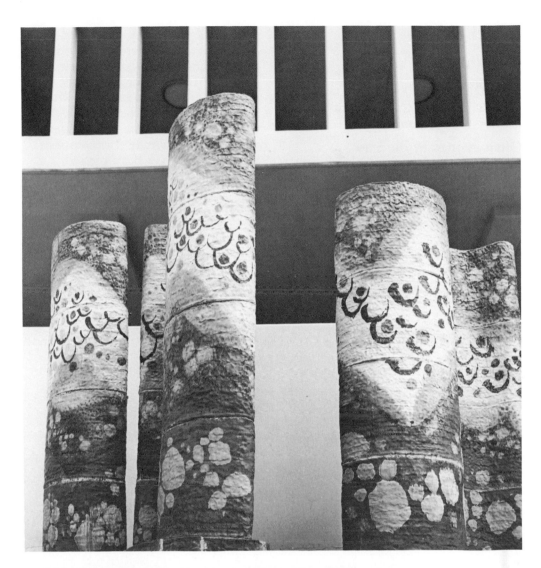

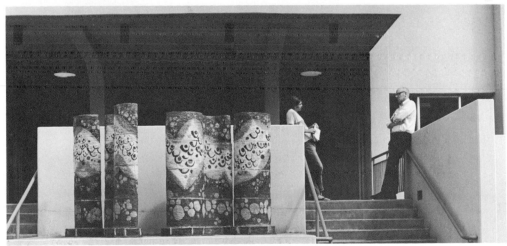

Isami Enomoto

Untitled

Ceramic. 1964

Kuykendall Hall, University of Hawaii, Manoa Campus

Commissioned by the State Comptroller

Four small sculptures, composed of myriad ceramic pieces, are poised over a long rectangular pool, forming a jewel-like fountain group for the courtyard of Kuykendall Hall. Water trickles slowly over and through the conglomeration of irregular shapes, wheel-thrown cylinders with cut-out sections, that have been pressed together. A matte white glaze, with brushed decorations of iron and cobalt in random patterns, has been applied over the stoneware surface. Whimsical ceramic "flowers" of red and yellow emerge from the water around the bases of the fountain.

Manoa

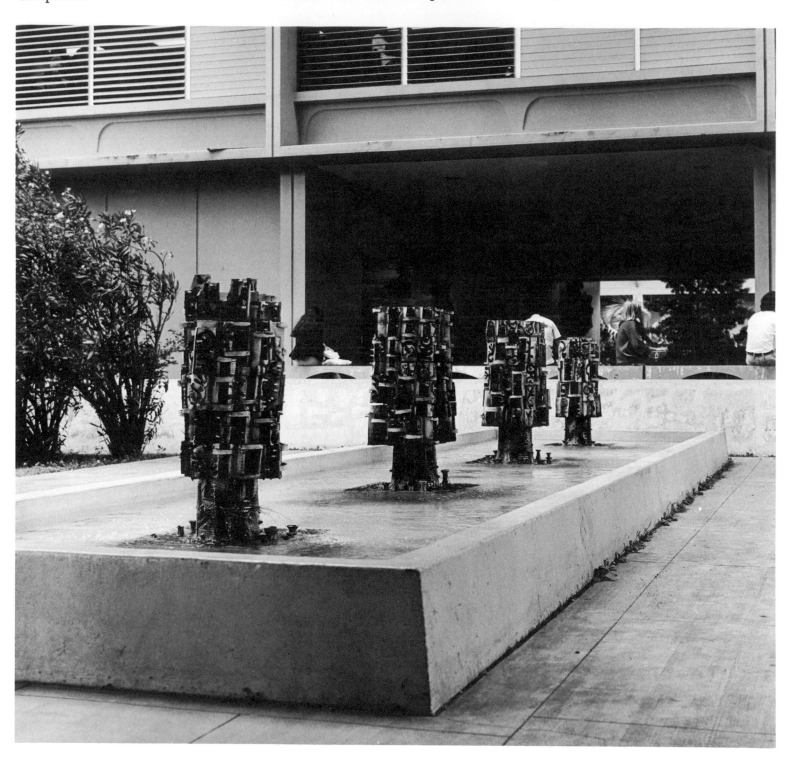

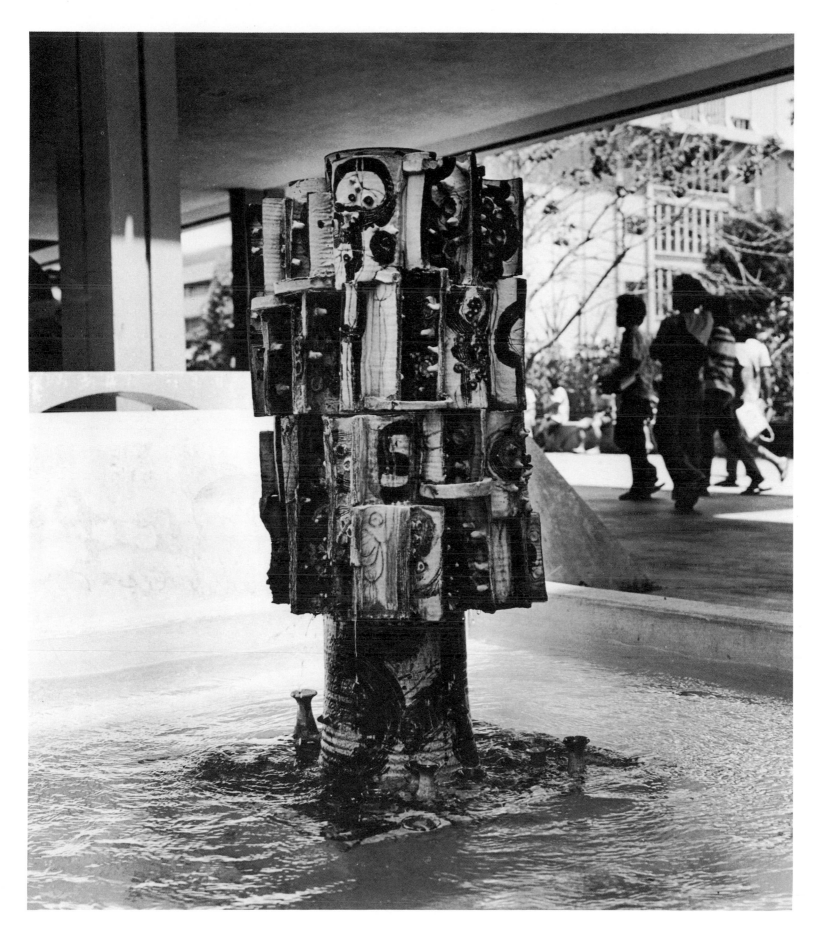

Gregory Clurman

Hina-O Na Lani

Granite. 1975

Campus Center, University of Hawaii, Manoa Campus

Commissioned by the State Foundation on Culture and the Arts

Of the sculptures included in this book, only four are made in the traditional manner of carving, the subtractive method of cutting or chiselling away of stone or wood. Much contemporary sculpture is cast or built up using a variety of techniques and materials. Gregory Clurman's *Mother of the Universe* is carved from a five-ton block of diamond pink granite from Minnesota. It typifies his approach to the medium, the selection of subjects whose forms and attitudes lend themselves to the proportions of stone block and the retention of the basic character of the stone. The origin of this work is evidenced by the quarry drill marks forming the hair patterns on the back of the head. The opposition of rough and smooth textures and the surface forms gives this piece a tactile quality which is pleasantly accessible by its location, centered in the busy approach to the Campus Center. The base of this six-foot sculpture is of highly polished emerald pearl granite.

Manoa

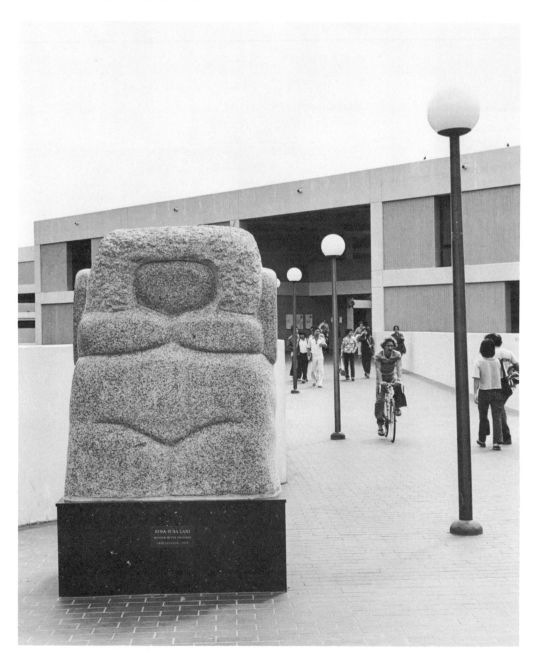

David Asherman

Water

Fresco. 1952

Bilger Hall courtyard, University of Hawaii, Manoa Campus

Commissioned by the State Comptroller

When Jean Charlot came to Hawaii in 1949, he painted almost immediately Hawaii's first true fresco for the ground floor of the university's administration building, Bachman Hall. Four of his pupils studying this technique of *buon fresco* subsequently designed the first outdoor frescoes in the Islands, which were located in the then new chemistry building, Bilger Hall. The four murals, completed between 1951 and 1953, depict the ancient Greek concept of the basic elements, fire, water, earth, and air, presented in terms of Hawaiian culture. Richard Lucier's *Fire* was the first, followed by David Asherman's *Water* in 1952, and Sueko Kimura's *Earth* along with Juliette May Fraser's *Air,* the largest of the series, in 1953. In *buon fresco,* a technique which has not altered substantially since the fifteenth century, when it was used by the masters of the Italian Renaissance, pure pigment, ground in water, is applied to a fresh mortar surface made of lime and sand. The palette is limited to pigments that are lime resistant. In Asherman's fresco, photographed here, the broadly painted figures, in sensitively applied muted browns and greens, depict the water finders in Hawaiian myth. Kane, accompanied by Kanaloa, thrusts his staff into a hole in a rock, and water gushes forth. The vegetation in the mural is tree ferns, the original plants of the courtyard.

Manoa

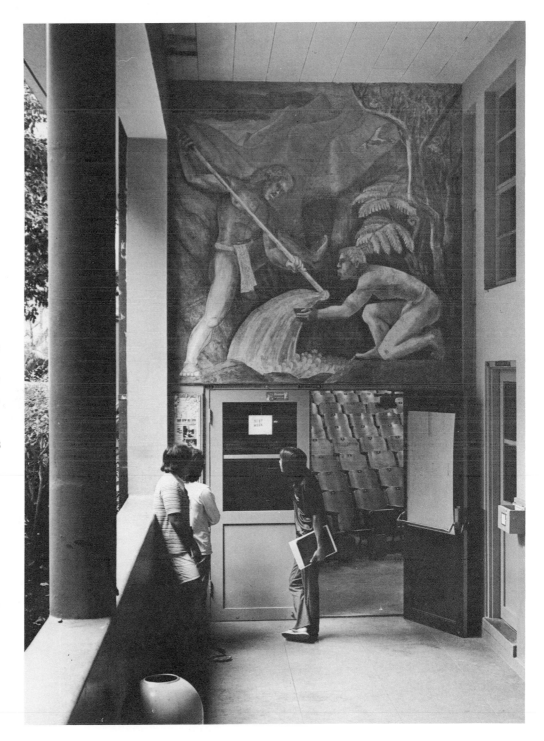

Harold Tovish

Epitaph

Bronze, steel, granite. 1970

Hamilton Library, University of Hawaii, Manoa Campus

Commissioned by the State Foundation on Culture and the Arts

Tovish was fascinated with the armored helmets of the Middle Ages and here adapts the theme to portray a fractured and physically constrained expressionless face of bronze. Set in a stainless steel enclosure, the features suggest dilemmas of modern man, while the black granite cross forms of the sculpture reflect his present fleeting image.

Manoa

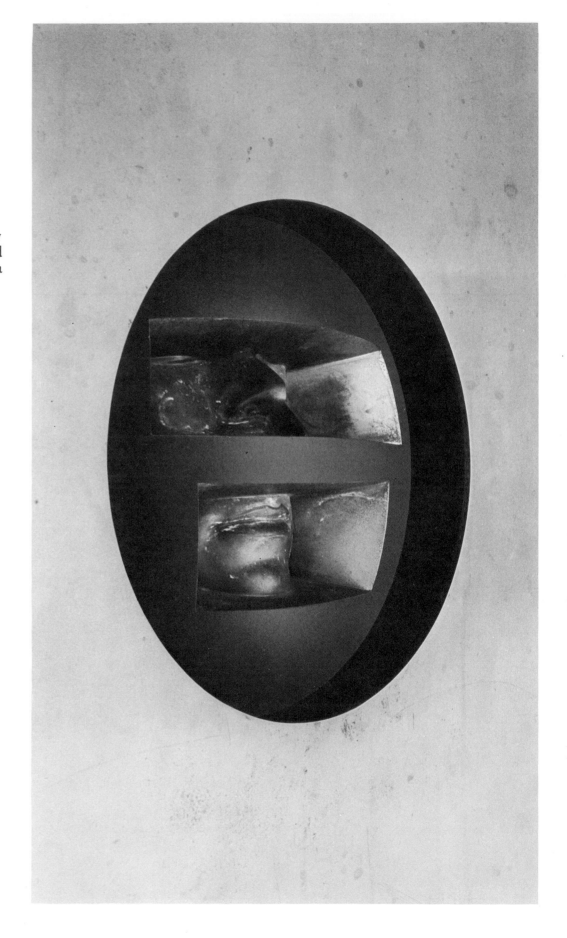

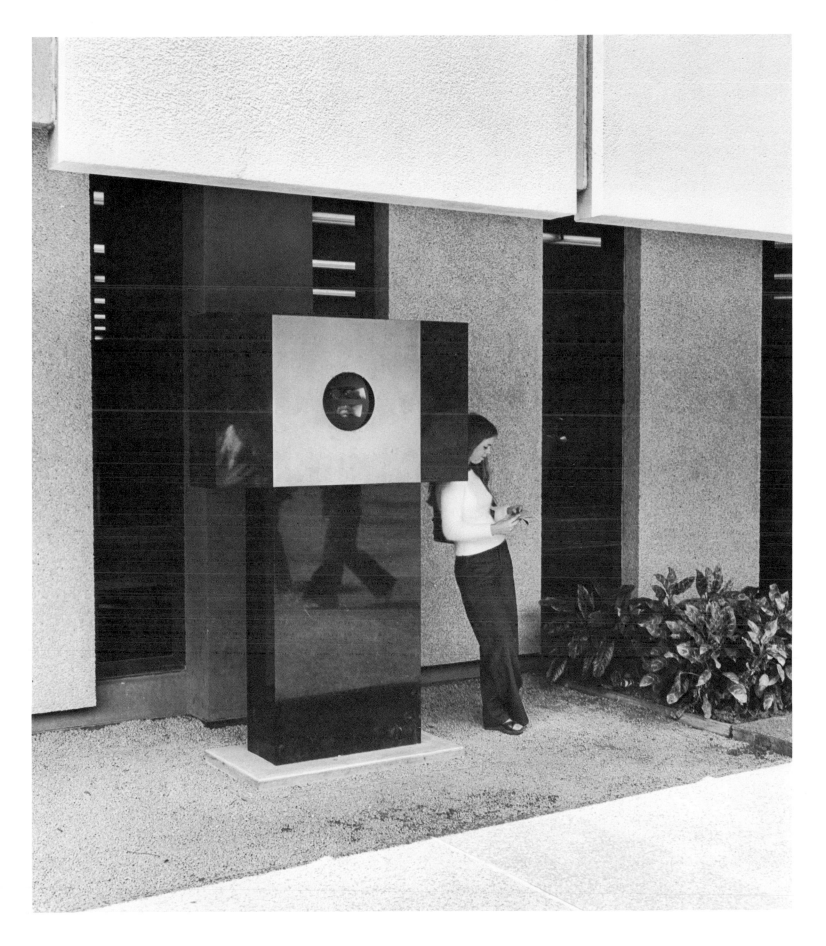

Charles Watson

To the nth Power

Weathering steel. 1973

Business Administration Building, Maile Way at University Avenue, University of Hawaii, Manoa Campus

Commissioned by the State Foundation on Culture and the Arts

Five hollow circle forms, varying in diameter and piled to a height of twelve feet, are a reference to the money of Yap Island in the west Pacific and man's concern for the accumulation of wealth. Watson's sculpture is cut, formed, and welded of one-half-inch steel plate which weathers to a deep rust, slightly mottled with mill scale. The dark circles, set upon a base surfaced with Waianae river rock, are handsomely complemented by the color and textures of their architectural setting.

Manoa

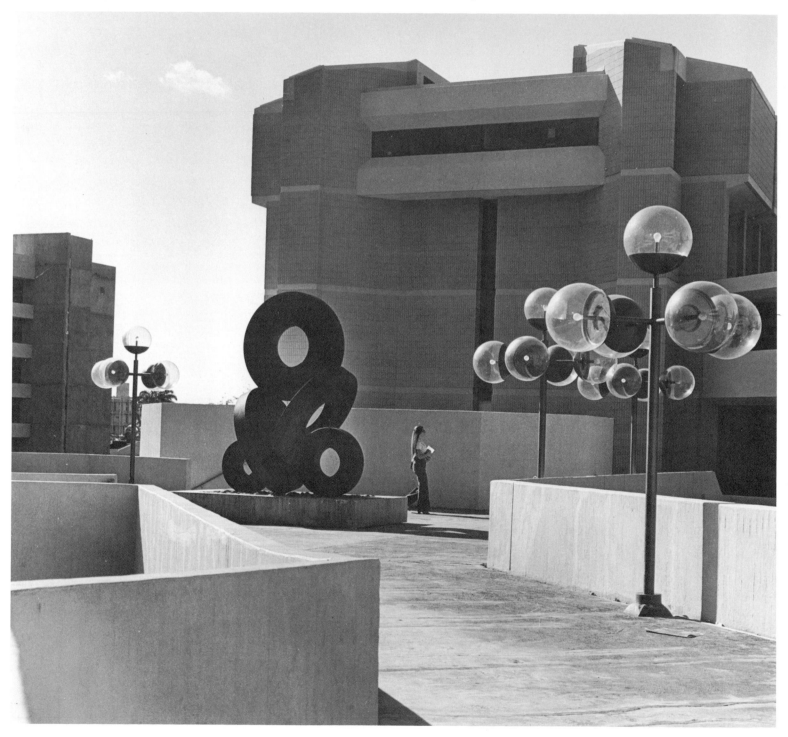

Otto Piene

Pleiades

Prisms and steel rods. 1976

Institute for Astronomy, University of Hawaii, Upper Manoa Campus, 2680 Woodlawn Drive, Honolulu

Commissioned by the State Foundation on Culture and the Arts

On the courtyard wall of the new Institute for Astronomy, Otto Piene's sculpture dazzles the eye with a continuous show during the sunlight hours. Over one hundred and fifty prisms, at the end of stainless steel rods, are mounted horizontally from the wall, their arrangement representing the star field of the Pleiades, the Seven Sisters. The theme is based on the group of stars which was important to the Polynesian calendar system. The Sisters themselves are the most complex prism clusters, consisting of units of four quadrants, each of which contains a pyramidal prism, thereby creating a total of sixteen surfaces. Two other stars are each composed of three prism clusters. The spectral projections originating from

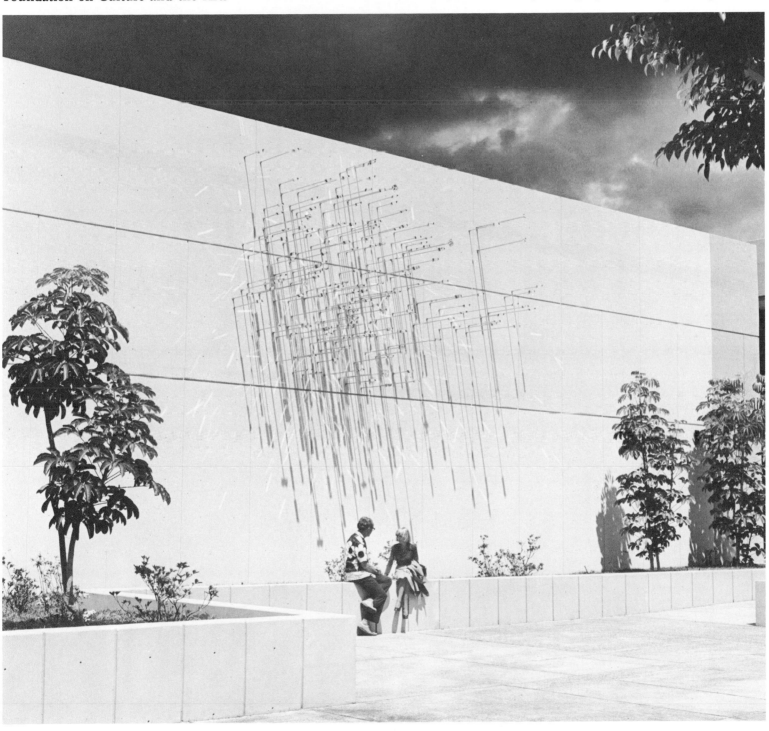

the prisms and shadows of the rods
create constant color and pattern
changes in the courtyard, which vary
with time and seasonal changes.

Manoa

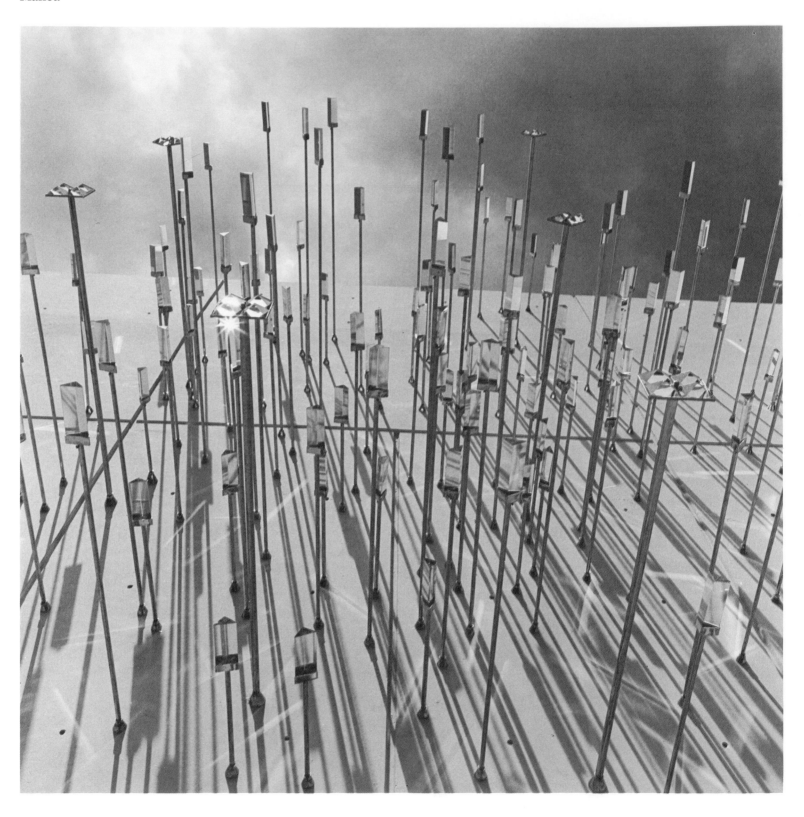

Edward M. Brownlee

Untitled

Concrete. 1971

Hawaiian Electric Substation, Leahi at Hollinger Streets, Honolulu

Commissioned by Hawaiian Electric Company

This sensitive approach to the wall treatment of a substation has resulted in the enhancement of a predominantly residential neighborhood, in the same spirit as the thoughtful design of the Waikiki Fire Station directly across the street. No attempt was made to ignore the composition of transformers, insulators, and wires behind the wall—rather the design, derived from electrical circuitry patterns, relates to it. The eight-foot by fifteen-foot concrete mural is approximately one foot thick and was cast in place against polystyrene forms.

Waikiki

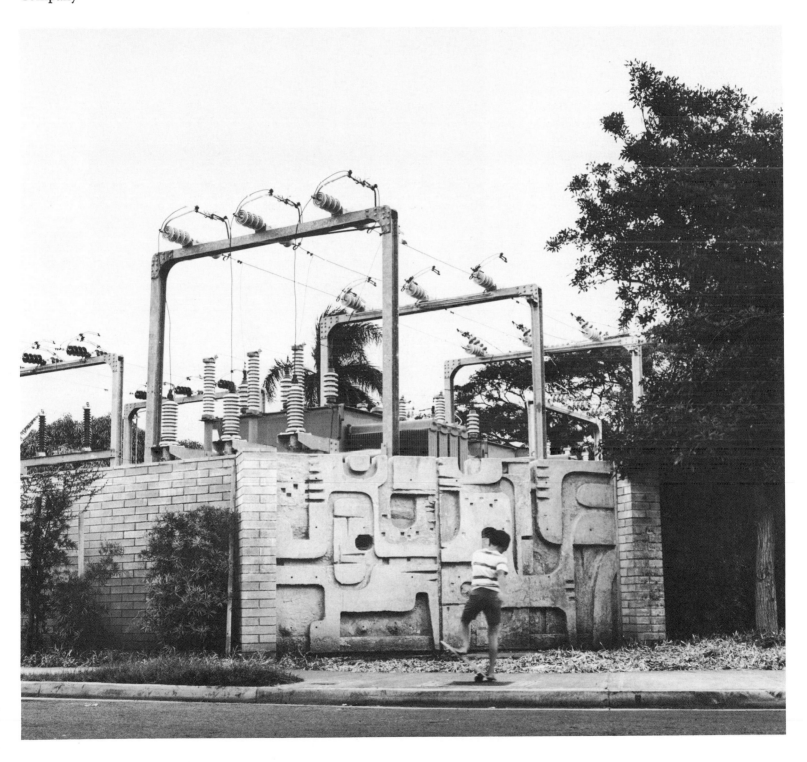

Kay Mura-Davidson

Hawaiian Image

Ceramic. 1972

Hawaii School for the Deaf and Blind,
3440 Leahi Street, Honolulu

Commissioned by the State
Foundation on Culture and the Arts

One professional artist and one hundred and eighty students of the Hawaii School for the Deaf and Blind pooled their talents and enthusiasm to produce a lively ceramic mural for the school grounds. A theme—the world of nature in the Islands—was selected, and each child set to work creating his own design. A fantastic assortment of creatures evolved. Arranged in horizontal bands representing ecosystems of ocean floor, sea, land, and sky, they were glazed with appropriate colors: rich orange, brown, and shades of blue and green. Transparent glaze was used on the figures to retain maximum tactile quality. The entire eight-foot by twelve-foot panel was then divided into tiles which were individually fired before being reassembled.

Waikiki

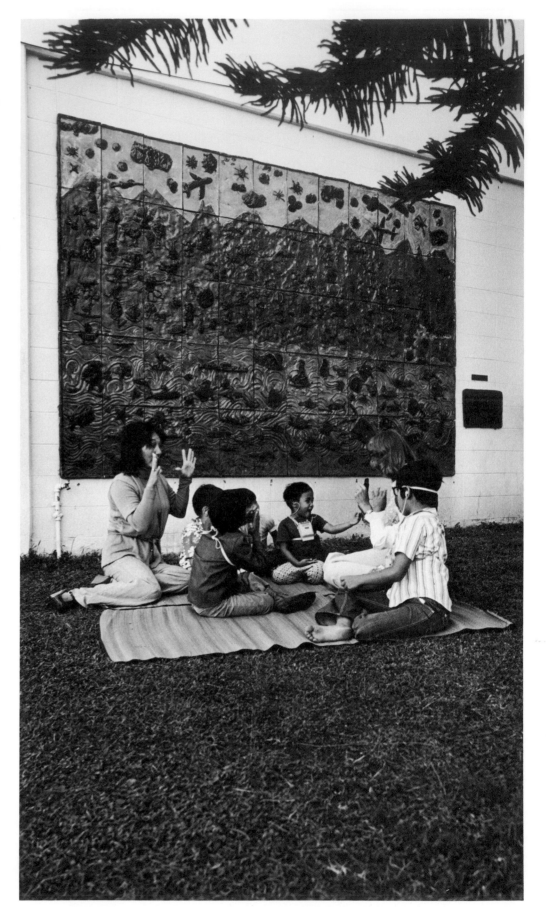

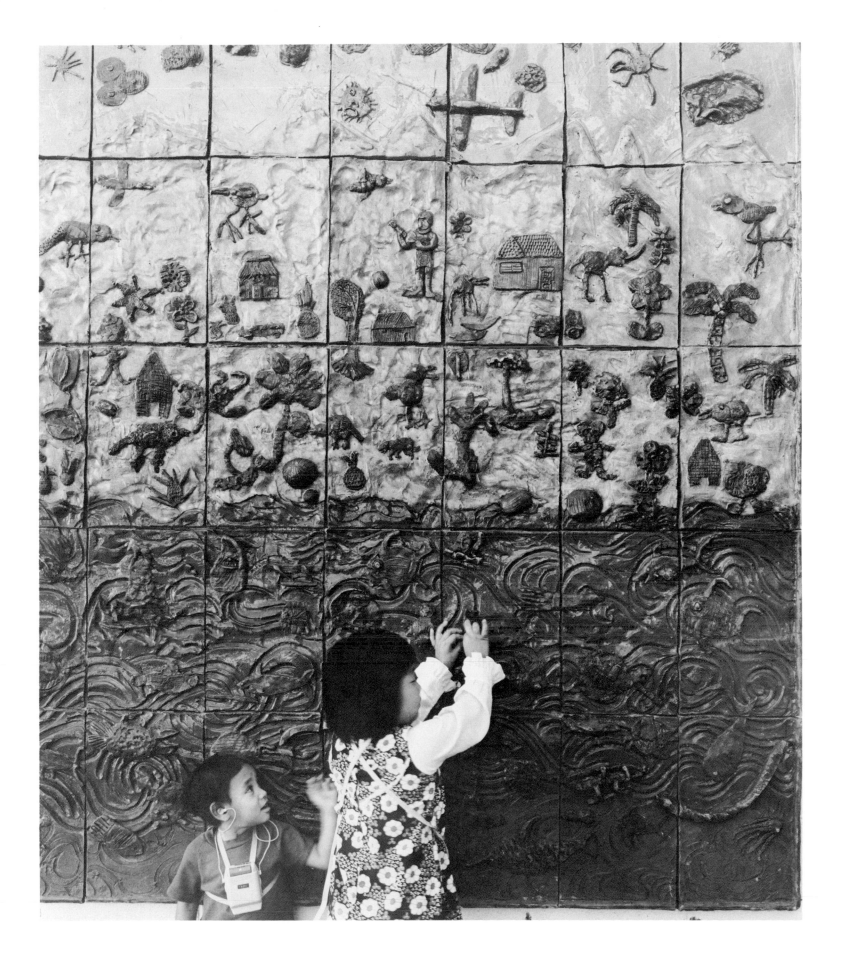

Walters, Kimura and Associates, Inc.

Untitled

Concrete. 1973

Kapiolani Park, Monsarrat Avenue between Paki and Leahi streets, Honolulu

Commissioned by Island Federal Savings and Loan

"To create an environment, with motivation through play, in which physically handicapped children could function freely and acquire experience similar to that of other children. . . . " This program statement, related to play learning experiences, applies directly to the design of this project by George Walters. Located in Kapiolani Park near the Hawaii School for the Deaf and Blind, this play sculpture was designed for the use of children both with and without physical handicaps. A circular maze, swinging rope bridge, climbing structures of concrete poles and auto tires, and a "tactile alphabet cylinder" are integrated into a handsome composition, surrounded by a grassy, tree-shaded mound ideal for comfortable adult supervision.

Waikiki

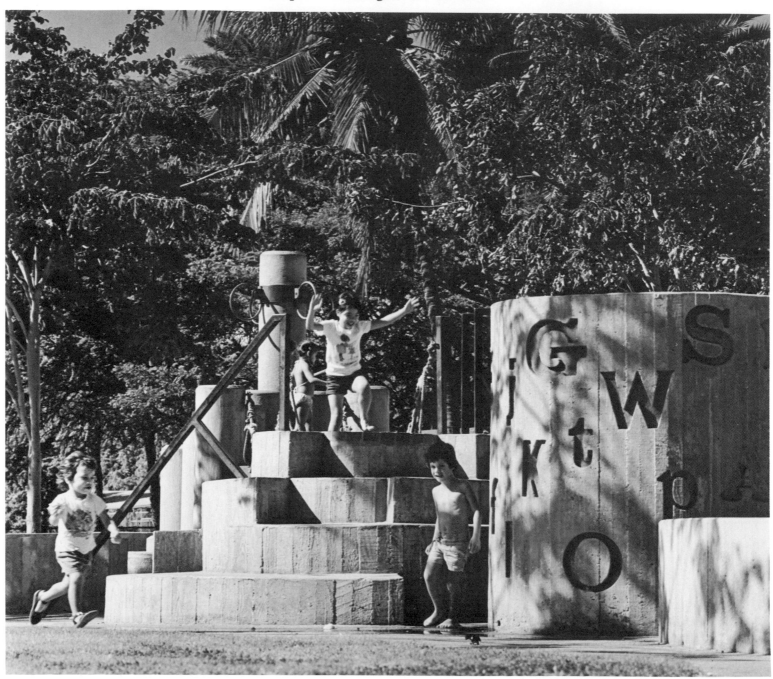

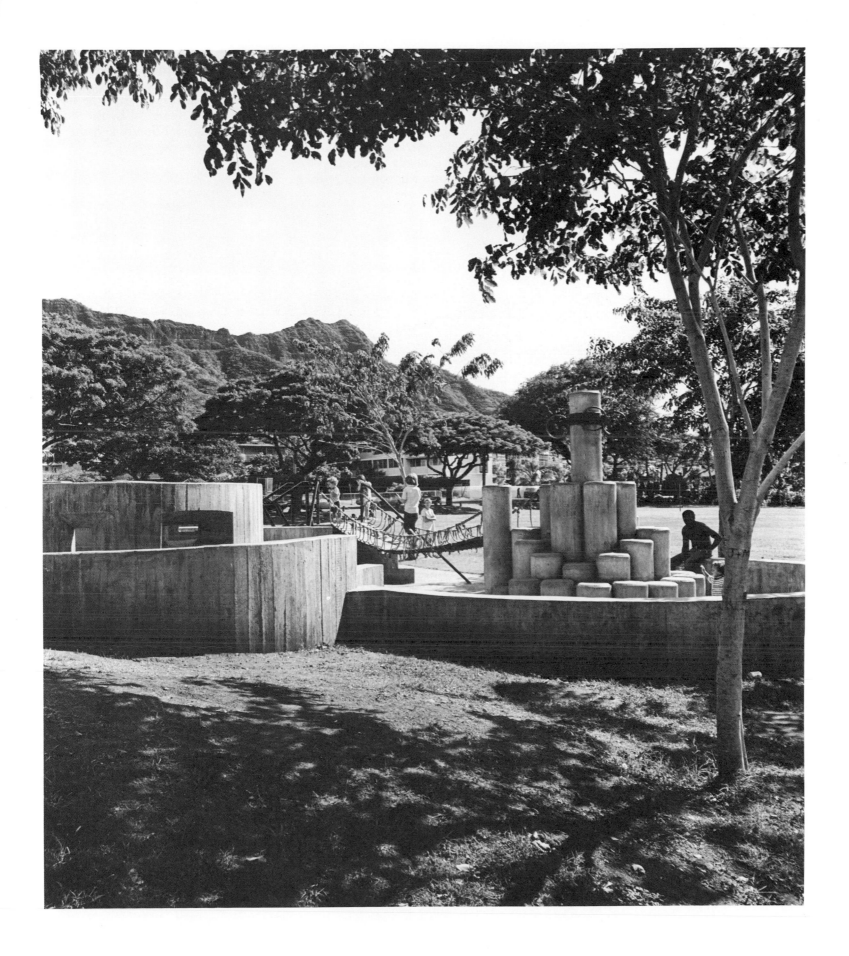

Jay Anderson

Gurgoyle

Steel. 1975

Kahala Elementary School, 4559
Kilauea Avenue, Kahala

Commissioned by the State
Foundation on Culture and the Arts

This imaginative adaptation of a
molasses extractor, salvaged by Ander-
son from the old Kohala Sugar Mill
on the island of Hawaii, has produced
a handsome contemporary fountain
while preserving a link with Hawaii's
past history. The operational principle
of the extractor is neatly retained, as
water pumped into the new top cylin-
der of weathering steel flows down
and out through the perforated lower
cylinder and splashes into a circular
pool. The dark rust color of the steel
fountain is nicely set off by the white
walls of the school library and the
purple-toned *hemigraphis*.

Kahala

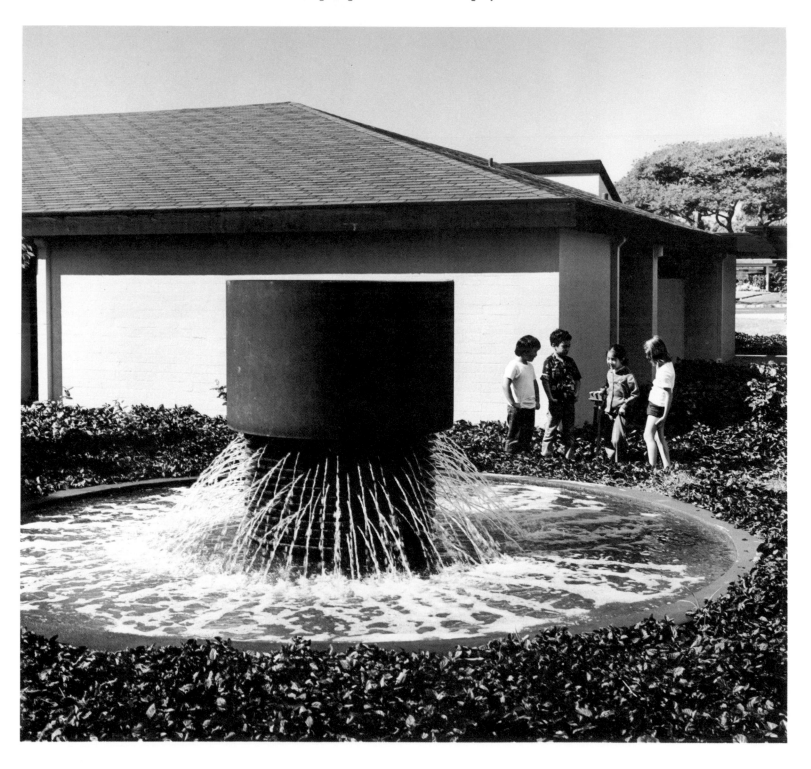

William Mitchell

Mayan Ruins

Cast concrete. 1972

Niu Valley Intermediate School, 310 Halemaumau Street, Niu

Commissioned by the State Foundation on Culture and the Arts

Twenty-four concrete columns, ranging in height from two to ten feet, are arranged in three clusters forming a broken fence which screens the school grounds from the street. Each column section is decorated with intricate geometric patterns reminiscent of pre-Columbian ruins. They are popular with the students for climbing, sit-ting, and as a lunchtime "forum" and gathering place. The styrofoam forms were made at the artist's studio, then in San Francisco. The units were cast off-site in Honolulu and then sandblasted.

Niu

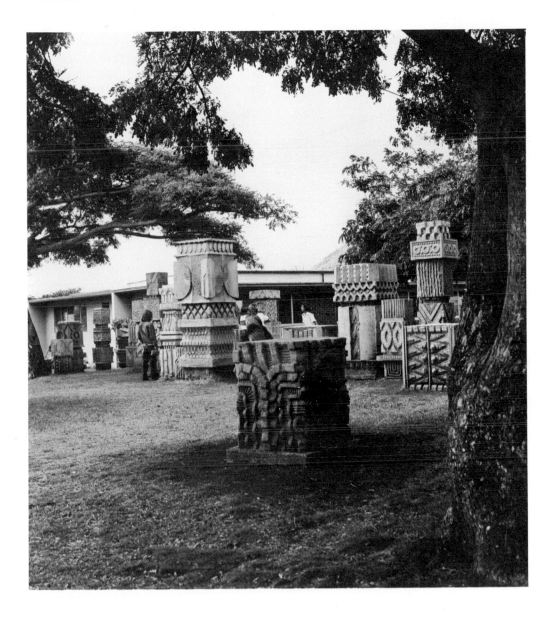

Juliette May Fraser

principal artist;

David Asherman,

production coordinator

Ka Haku Beniamina

Ceramic tile. 1972

Benjamin Parker Elementary School,
Kamehameha Highway and Waikalua
Road, Kaneohe

Commissioned by the State
Foundation on Culture and the Arts

At the Benjamin Parker School in
Kaneohe, a fifty-six-foot ceramic tile
mural commemorates the school's
founder, Benjamin Parker, the mis-
sionary who established the first mis-
sion station and school on Windward
Oahu in the 1840s. The mural, con-
ceived as a triptych, depicts the edu-
cational and musical activities and
the sports and games of the mission.
Members of the Parker family are
included, with *Ka Haku Beniamina*
"the Reverend Benjamin" at the
bass. The scenes, in soft yellows,
greens, and browns, are separated by

"curtains" of dark blue-green foliage
of the *hala* trees and bamboo. Miss
Fraser, with David Asherman and two
other artists, Mataumu Alisa and
Dixie Samasoni, spent a summer in
Puebla, Mexico, where they estab-
lished a studio near the Casa Rugerio
Ceramic Factory. After adapting Miss
Fraser's cartoon to approximately
fifteen hundred Talavera tiles, the ar-
tists worked with the factory during
the glazing and firing process. Felipe
Rugerio, owner of the factory, came to
Hawaii to assist in the installation. On
the right-hand return of the mural,

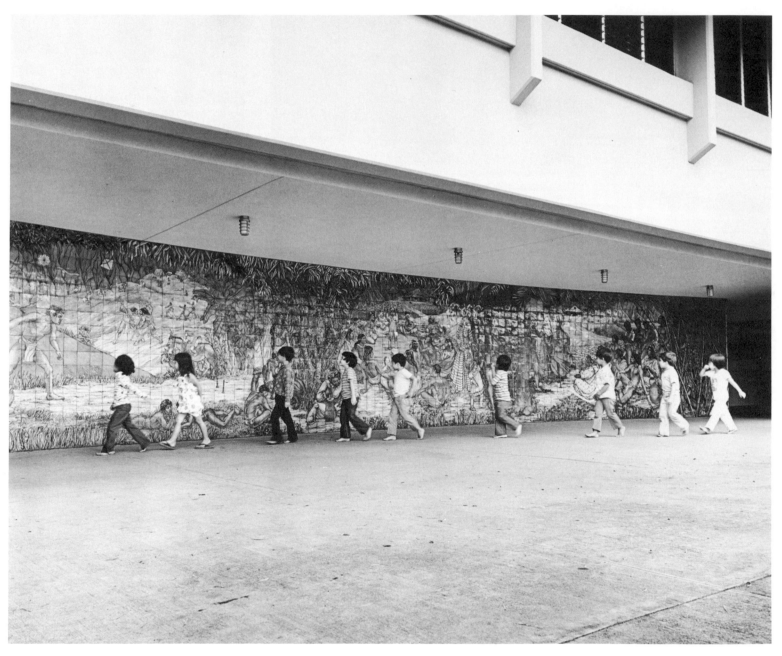

the cooperative nature of the project is
illustrated by a billboard of ''credits.''

Windward Oahu

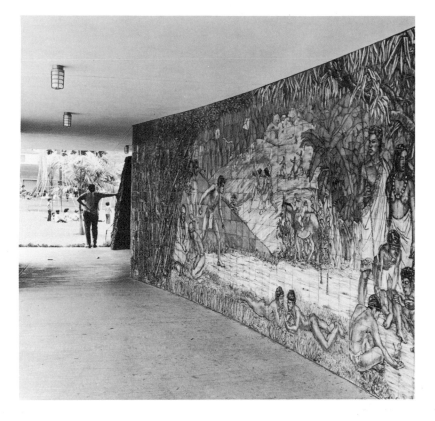

Satoru Abe

Three Rocks on a Hill

Copper and bronze. 1975

Honolulu Community College
Library, 874 Dillingham Boulevard,
Honolulu

Commissioned by the State
Foundation on Culture and the Arts

The sculptures in this group of three
are provocative in suggesting geologic
natural forms yet exploiting the man-
made quality of their intricate fash-
ioning and craftsmanship. Over a
sculptural framework, copper plate is
brazed, then covered with patterns of
metal strips and puddled bronze in
relief. As the metals weather, their
browns, reds, and golden tones
deepen, producing a rich patina. The
casualness of the pieces' siting, in
relation to the building, seems to em-
phasize their enigmatic quality.

Ewa of downtown

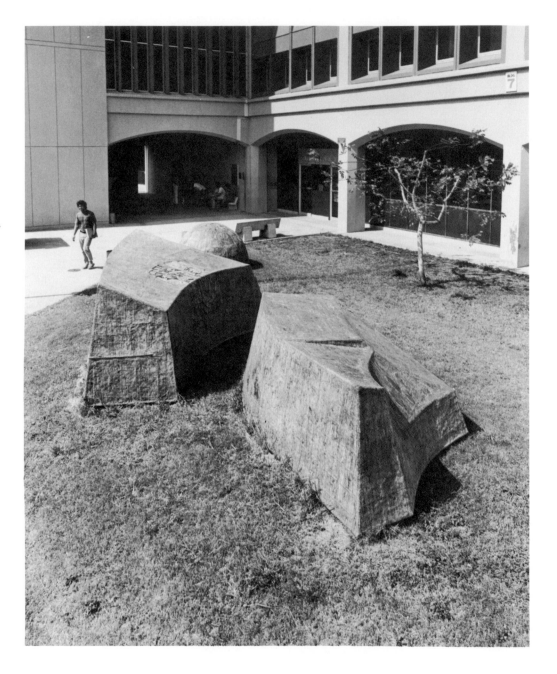

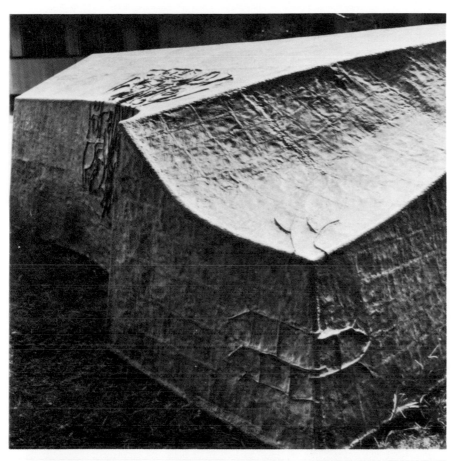

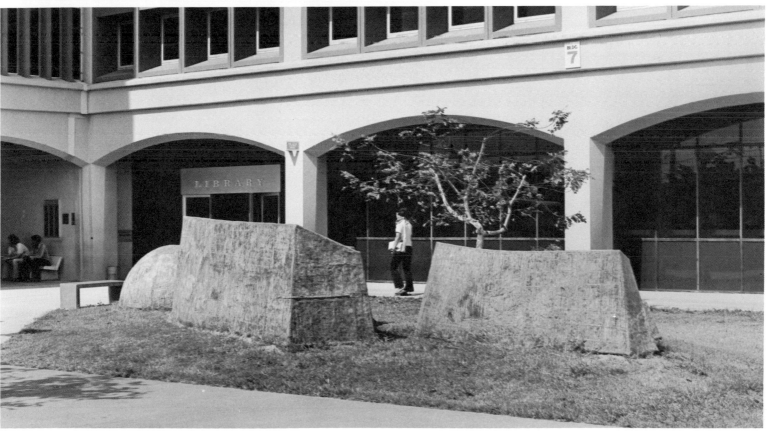

Kay Mura-Davidson

Play Forms

Ceramic. 1973

Likelike Elementary School, 1618 Palama Avenue, Honolulu

Commissioned by the State Foundation on Culture and the Arts

Small-scaled and playful in intent, Kay Mura-Davidson's multipiece sculpture for children is set on a base of handmade round ceramic tiles. The nine stoneware units come very close to "being something," but not quite, providing the fun of individual fantasy and discovery. The sculpture's forms were built by coil method and filled with polyurethane for reinforce-

ment. Bright majolica glazes in blues and yellows are applied in bold patterns, into which are set children's verses of poetry in Hawaiian and English.

Ewa of downtown

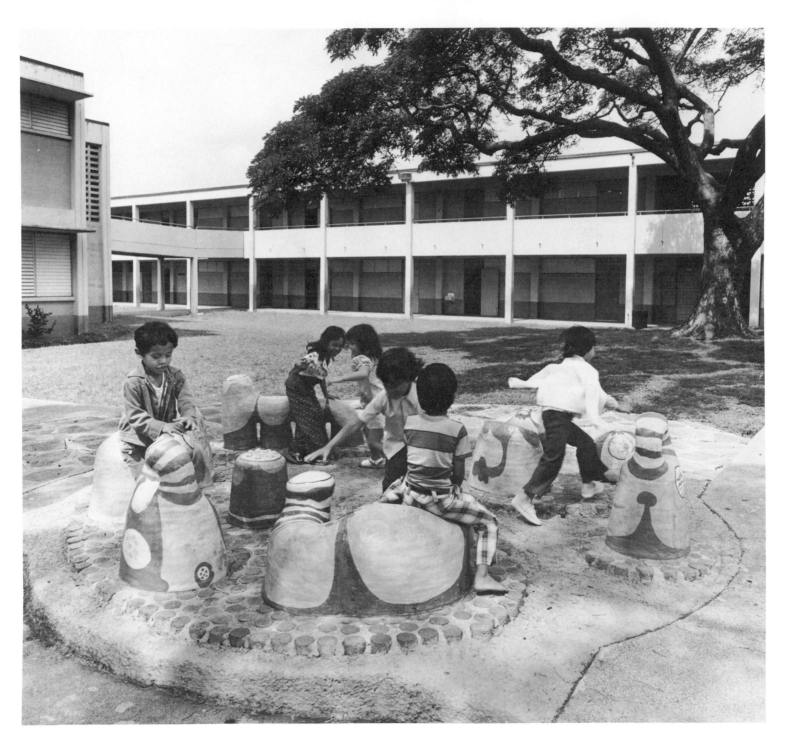

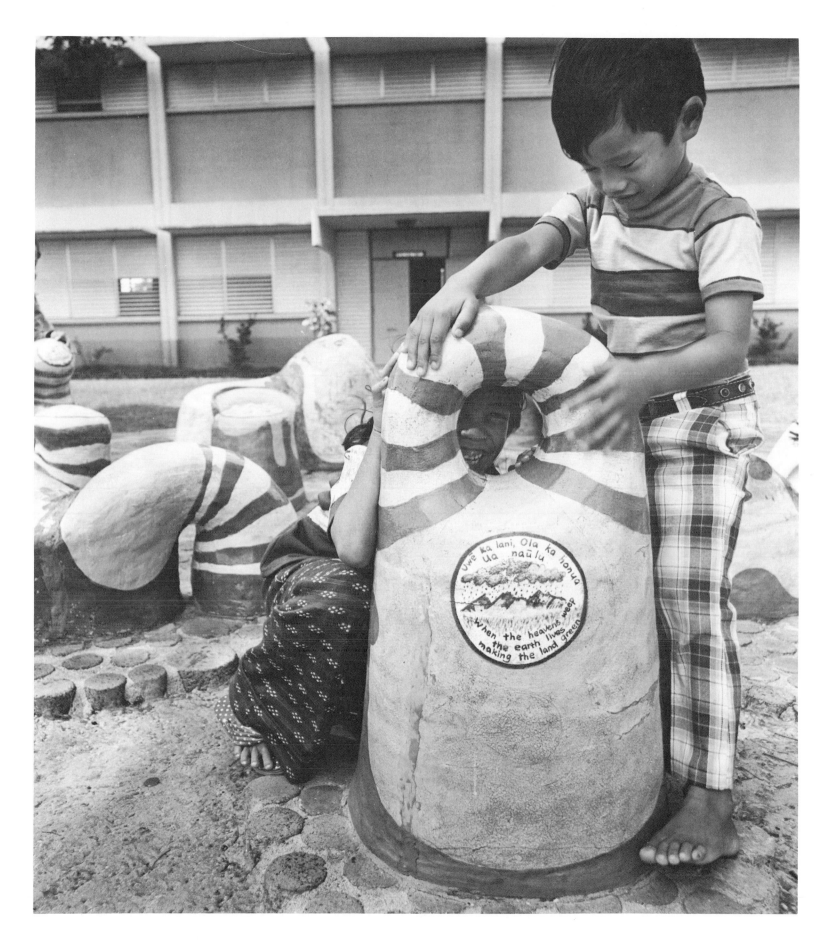

Jean Charlot

mural design;

Isami Enomoto,

ceramic technician

Untitled

Ceramic. 1970–1975

United Public Workers Building, 1426 School Street, Honolulu

Commissioned by the United Public Workers

One of the few unions in the United States to commission a work of fine art, the United Public Workers—a union of government employees and hospital workers—selected Jean Charlot, a distinguished artist of Hawaii, to design a six-panel mural for its headquarters building. The work was achieved as a collaboration with Isami Enomoto, who executed the exacting technical aspects of color control, glazing, and firing of the twelve-inch by twelve-inch tiles. The

end panels illustrate union demonstrations. Four center panels, depicting the major divisions of the U.P.W., were conceived at union meetings in close cooperation with the rank-and-file members, some of whose portraits occur in the figures. One panel, representing the City Refuse Division, has humorous touches: the Primo six-pack offered as a bribe for "extra service." We see the laundry workers at St. Francis Hospital, the Road Repair and Board of Water Supply workers, and

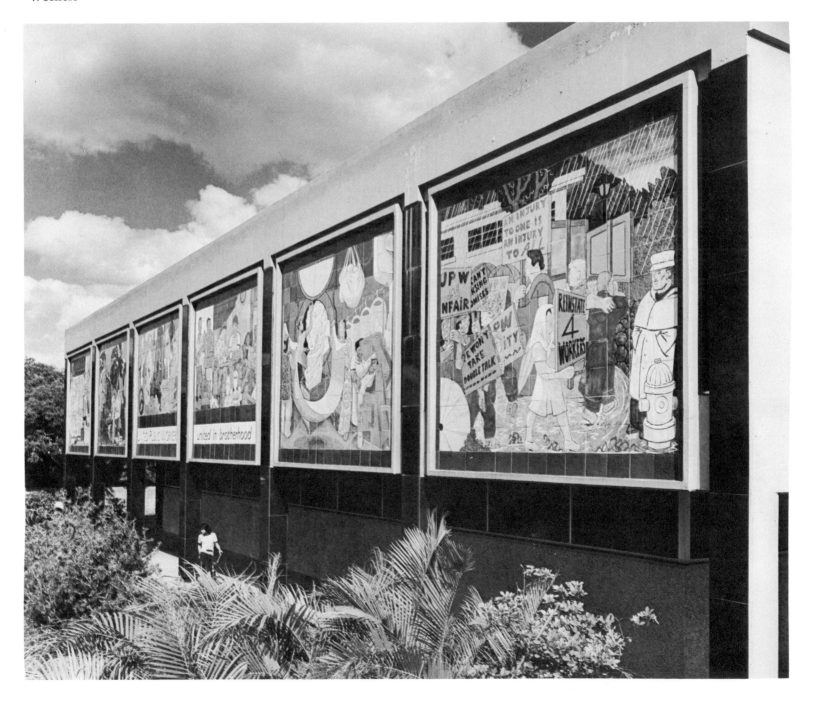

the School Custodial and Cafeteria Division, represented by bold, simplified figures in the tradition of the Mexican mural revival and characteristic of Charlot. The panel on the left end has a special spirit of warmth—a peaceful demonstration during the 1970 legislative session, held at the State Capitol under the statue of Father Damien, in which a mother and son dance an impromptu hula accompanied by bass and guitar. Charming accents of bright red appear in all panels, as in the lei at Father Damien's feet.

Ewa of downtown

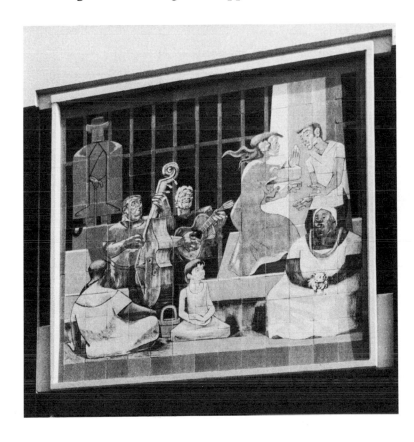 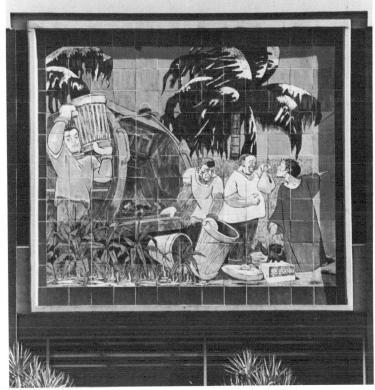

Ken Shutt

Sky Sailor

Mixed Media. 1974

Hawaiian Air Academy, 3030 Aolele Street, Honolulu Airport

Purchased by the Hawaiian Air Academy

Soaring over a small garden on the deck of the Hawaiian Air Academy, *Sky Sailor,* a sculpture with a nineteen-foot wingspan, vibrates when the trade winds are up. In constructing this inventive work, Shutt selected the lightest materials. Spruce was used for the wing struts. The figure was shaped from fiberglassed styrofoam, coated with an epoxy resin saturated with bronze powder. It was then oiled and polished to produce a finish with the quality of dark leather. Wings were anchored to the body by an inner fiberglass "collar," guyed by barely perceptible wires to the redwood pylon. The tensile assemblage of ribs and wires, suggesting ancient flying machines, is a whimsical recollection of the Icarus legend.

Ewa of downtown

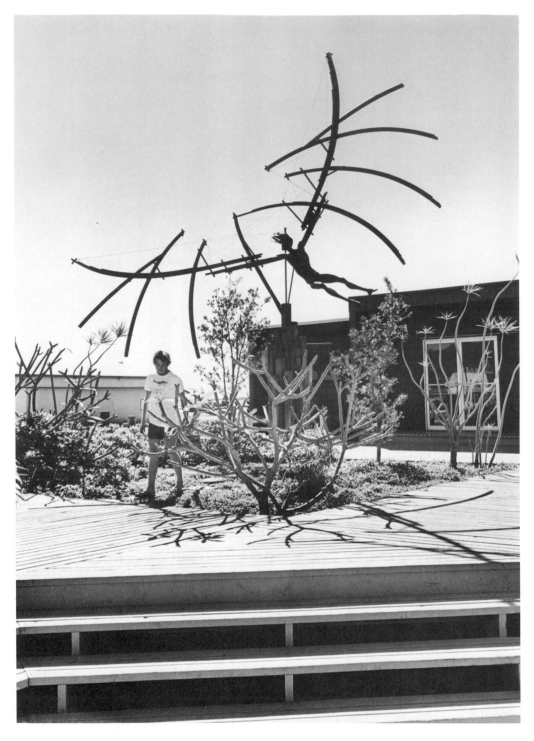

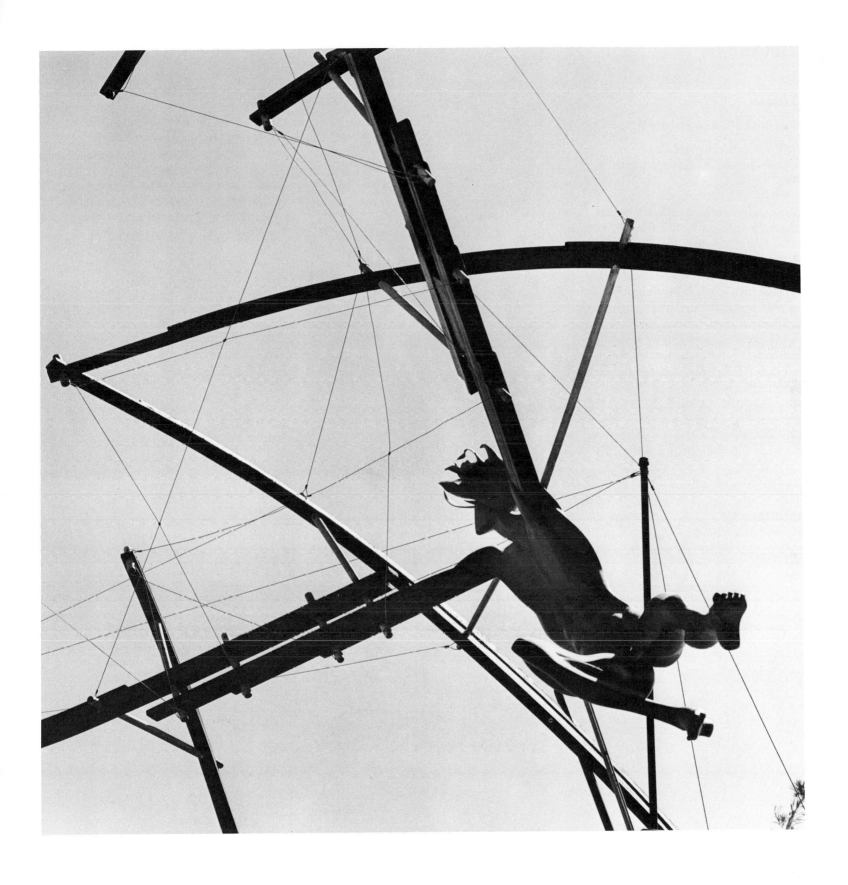

Mamoru Sato

Dyad

Terrazzo. 1974

Honolulu International Airport

Commissioned by the State
Foundation on Culture and the Arts

The double-form sculpture, *Dyad,*
originally placed to be viewed from
the "Y" concourse of the airport ter-
minal building has been relocated in-
to the garden at the entrance to the
parking structure. The obliquely
halted, powerful upward thrust of the
sculpture's forms is a spirited response
to the dynamics of this environment.
Sato's polyester resin model, scaled up
to twenty-four feet, was constructed
by the Pacific Terrazzo and Tile Cor-
poration, using a three-inch scratch
coat applied to galvanized lath over a
steel framework. The finish material is
polished Dolomite terrazzo.

Ewa of downtown

Claude Horan

Cecil

Ceramic. 1976

Red Hill Elementary School, 1265 Ala Kula Place, Honolulu

Commissioned by the State Foundation on Culture and the Arts

A recent addition to the growing list of playsculptures at Hawaii's schools is Claude Horan's fanciful cluster of sculptures at Red Hill Elementary School. The surfaces of the objects are covered with bright, highly decorative patterns and figures, each piece unique. A giant head with bulbous ears emerges from the ground, its long neck beautifully decorated with bizarre birds. A five-piece serpent, appearing to move in and out of the earth, is "scaled" with a rich array of patterns, its body terminating in an incredible tail. Horan created these creatures with a combination of wheel-thrown and hand-built parts, using the decorative techniques of wax resist and scraffito and, for colors, clay slips covered with transparent glazes. There are more surprises in this menagerie at Red Hill.

Ewa of downtown

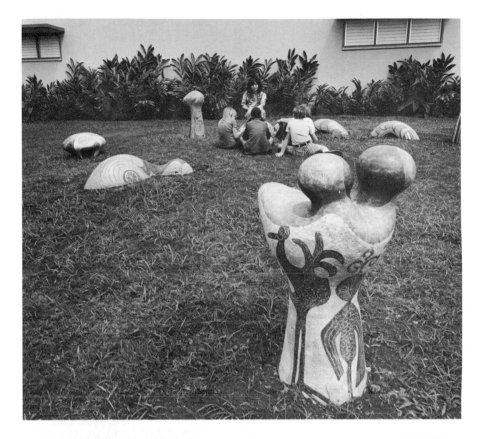

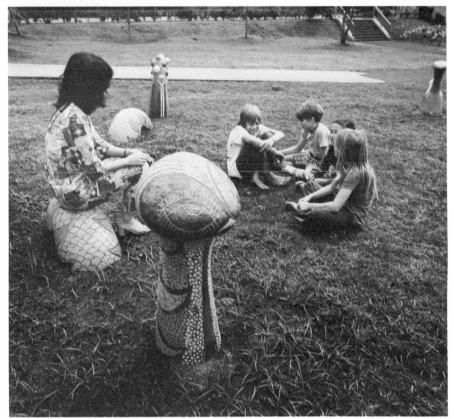

Johnson, Perkin and Preis;
Alfred Preis, F.A.I.A.,
Architect in Charge

U.S.S. Arizona *Memorial*

1962

Ford Island, Pearl Harbor, Honolulu

Funded by the 87th U.S. Congress,
the State of Hawaii, and public
contributions

Sponsored by The Pacific War
Memorial Commission

In designing the memorial to commemorate the loss of the U.S.S. *Arizona* and over a thousand of its crew on December 7, 1941, Alfred Preis recognized that the most profound emotional and historical experience would be evoked by viewing the battleship's hull itself and the remaining superstructure, as it now lies in thirty-eight feet of water off Ford Island. The concept is a partially enclosed bridge—in the structural sense, a double cantilever of two concrete girders resting on prestressed piles, spanning across the *Arizona* and in the nautical sense, as a lookout forward and aft across the sunken deck and the harbor beyond. The simple sculptural form of the memorial is easily identified from the higher elevations back from the shore—a white marker, against the blue of Pearl Harbor. As one approaches by boat, the structure seems appropriately to float beneath the battleship's national ensign, flown daily in tribute.

Ewa of downtown

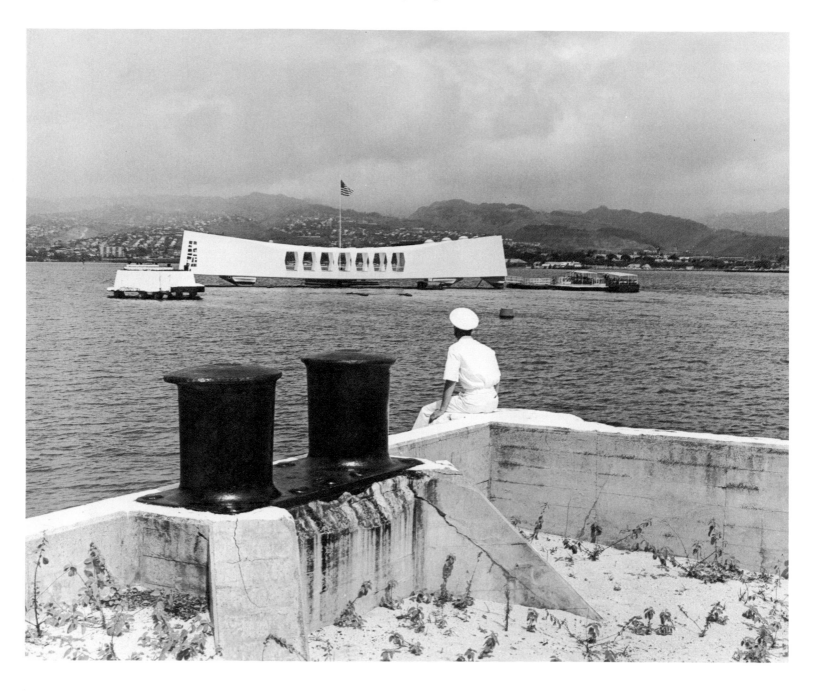

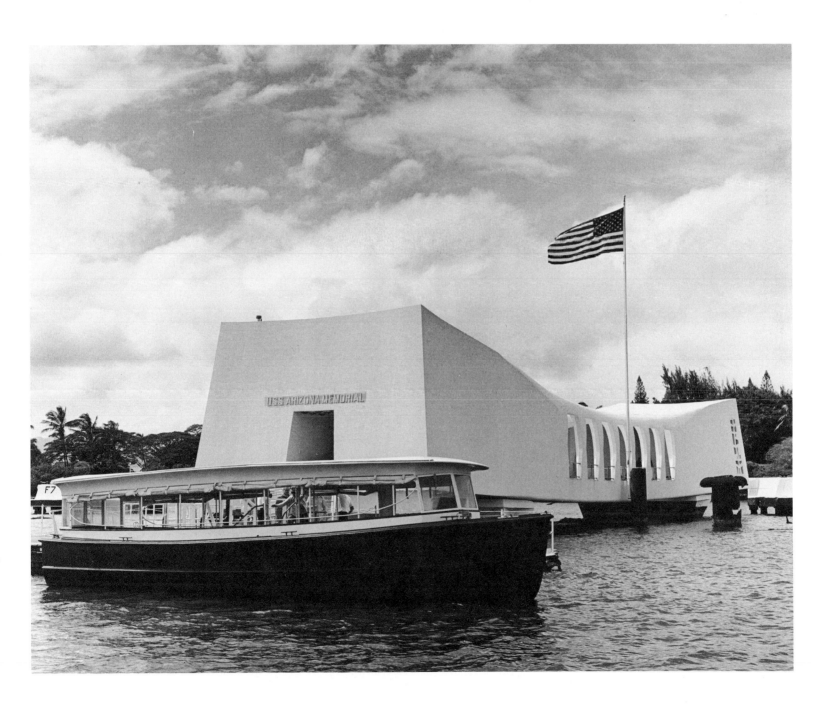

Satoru Abe

Among the Ruins

Copper and bronze. 1973

Leeward Community College,
Entrance fountain, 96–045 Ala Ike
Road, Pearl City

Commissioned by the State
Foundation on Culture and the Arts

This linear composition of Abe, ar-
ranged in islands in the curving
stairwell pool, combines in smaller
scale the irregular monolithic forms of
his Honolulu Community College
work and the branch forms of the
Nanakuli *Tree of Life*. The theme of
the origins and creativity of man
seems to pervade these constructions
of copper plate textured with bronze

patterns, whose rich colors are com-
plemented by the turquoise blue of
the pool.

Ewa of downtown

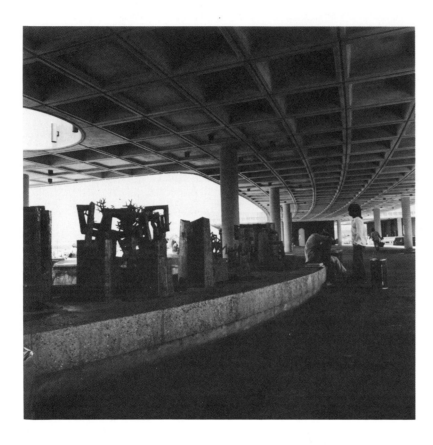

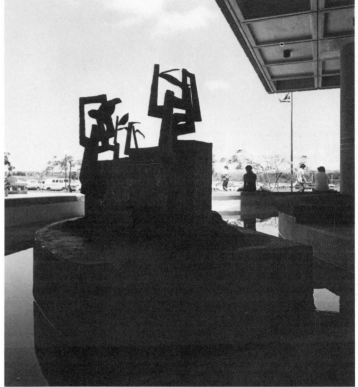

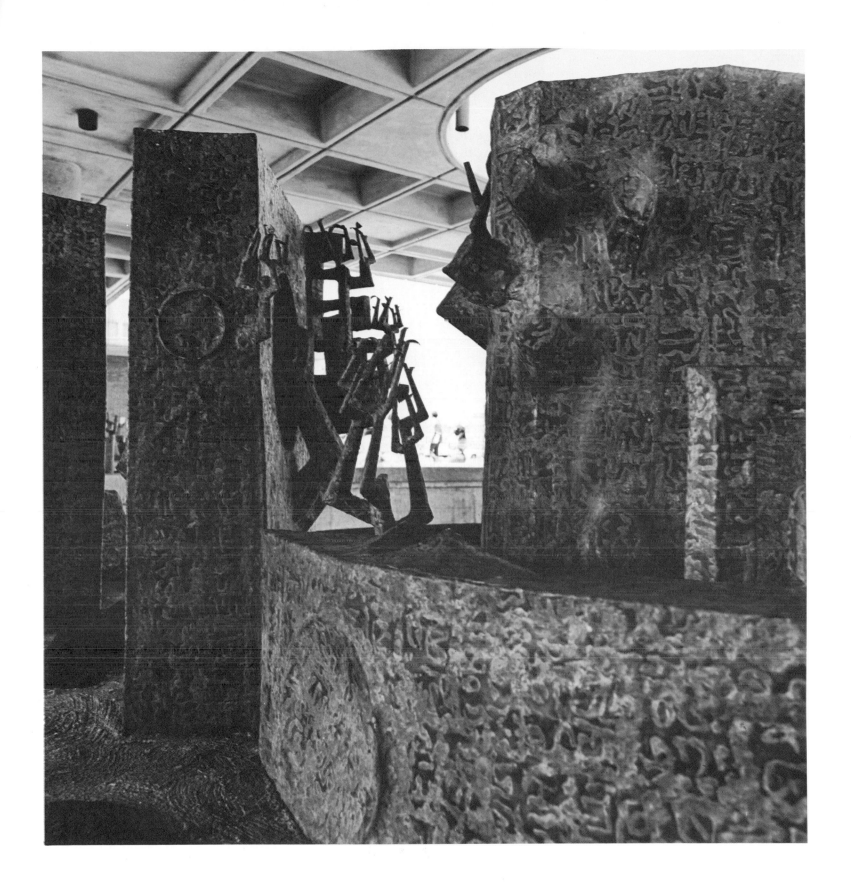

John Wisnosky

For the Tribe

Anodized aluminum. 1973

James Campbell High School, 91–980 North Road, Ewa Beach

Commissioned by the State Foundation on Culture and the Arts

Glimmering conical tapered poles, rising thirty feet into the sky, transcribe a circle sixteen feet in diameter at their grassy base. Each pole slopes inward five degrees toward the center and five degrees to the right, creating an upper opening of ten feet in diameter. When seen from a distance, with the poles viewed in two planes, an illusion of motion is created. The poles are of gold anodized aluminum, and their tops have been leveled and capped. Though the sculpture speaks for itself as a simple and powerful geometric statement, the artist suggests, by his title, another level of meaning—a circle of quivering spears.

Ewa of downtown

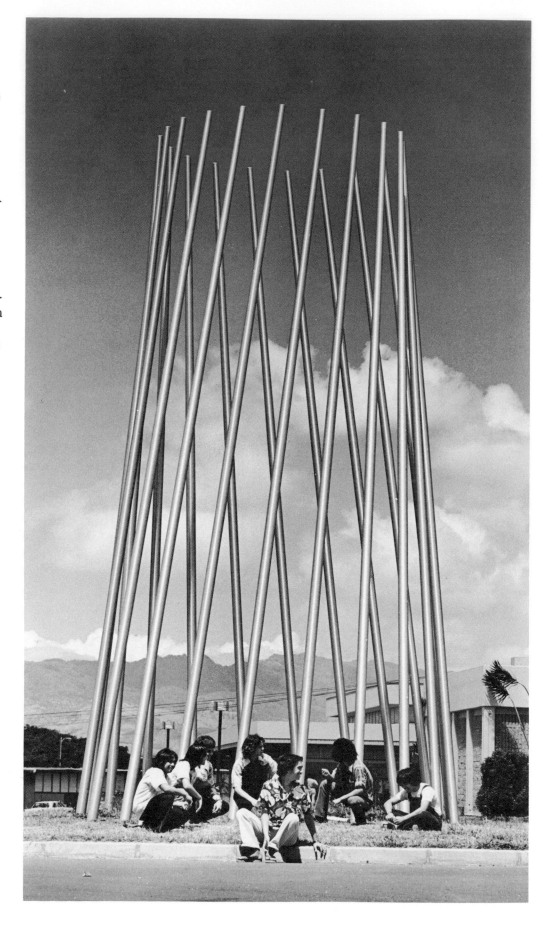

Satoru Abe

Tree of Knowledge

Copper and bronze. 1971

Nanakuli High and Intermediate School, 89–980 Nanakuli Avenue, Nanakuli

Commissioned by the State Foundation on Culture and the Arts

Sculpture and landscape are in perfect harmony in this circular inner court of the Nanakuli High School. The work, eight-and-one-half-feet high, is fabricated from copper plate, folded and brazed; the surface is enriched with puddled bronze and weathered to a subtle green-brown patina. The abstracted tree forms, monumental trunk bases, twisting branches, and leaf shapes, blend with their natural counterpart in a lush garden of strawberry guava, birds of paradise, and poinciana trees, with glimpses of the nearby Waianae mountain range through the foliage.

Leeward Oahu

Joseph Momoa;

supervised by Itsuo Tsukano

Huakaʻi and *Puu Maʻiliili*

Ceramic. 1973

Maili Elementary School, 87–360 Kulaaupuni Street, Maili

Commissioned by the State Foundation on Culture and the Arts

Many of the successful commissions of the State Foundation on Culture and the Arts have been for art in the public schools. A number of these have been concerned with the history of Hawaii, telling through murals and frescoes the stories of the past, whether fact or myth, and reaffirming pride in Hawaiian culture. This pair of ceramic tile murals at the library entrance of the Maili Elementary School, created by Joseph Momoa, a talented high school student under the supervision of his teacher, Itsuo Tsukano, explores the realm of myth. On the right, *Voyage,* alluding in dramatic perspective to prehistoric Polynesian migration, might also easily fit the contemporary scene. The theme of the left panel is an interpretation of the story of Chief Puu O Hulu, who was in love with Puu Maʻiliili, one of twin sisters whom he had difficulty telling apart. His problem was never resolved, for after a *moʻo* (a giant lizard) changed them all into mountains, he continued to be baffled by their similarity. The town of Maili lies between the hills of Puu O Hulu and Puu Maʻiliili.

Leeward Oahu

Joe Hadley

Buffalo's Cloak

Body cast. 1972

Waianae Library, 85–625 Farrington Highway, Waianae

Commissioned by the State Foundation on Culture and the Arts

Joe Hadley wanted his monument for the Waianae Library to be truly Hawaiian in spirit. He had also produced some sixty body casting "events," a process by which the form and power of a living figure can be spontaneously captured. The result was a "happening" on the beach, when Richard "Buffalo" Keaulana, surrounded by friends and relatives, and braced on a ladder over a deep air hole, was draped with plaster-soaked burlap. The folds pulled tight to his body, Buffalo stoically breathed oxygen through a tube for forty minutes under the hot sun. After another hour of laborious extraction, he finally emerged to applause and went for a swim. Later, the cast form was filled with layers of fiberglass-reinforced resin, sand, and pigment. The resulting figure captures the struggle of the Hawaiian people in the symbolism of Buffalo's ordeal. In the minds of many, the form also recalls the Marchers of the Night, warrior ghosts of Hawaiian mythology.

Leeward Oahu

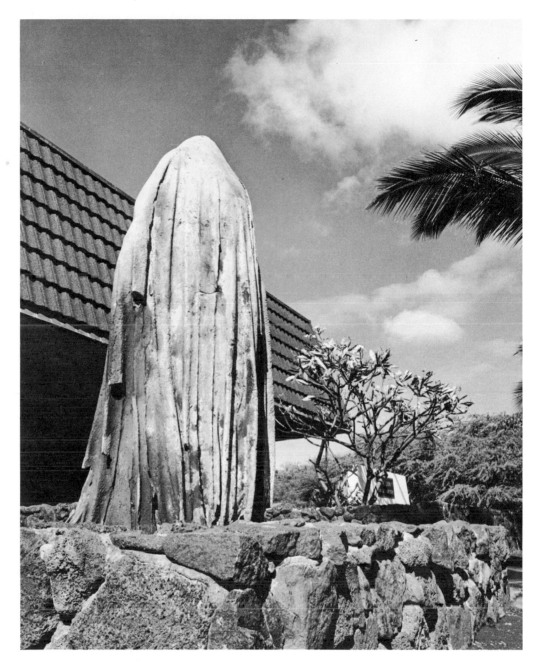

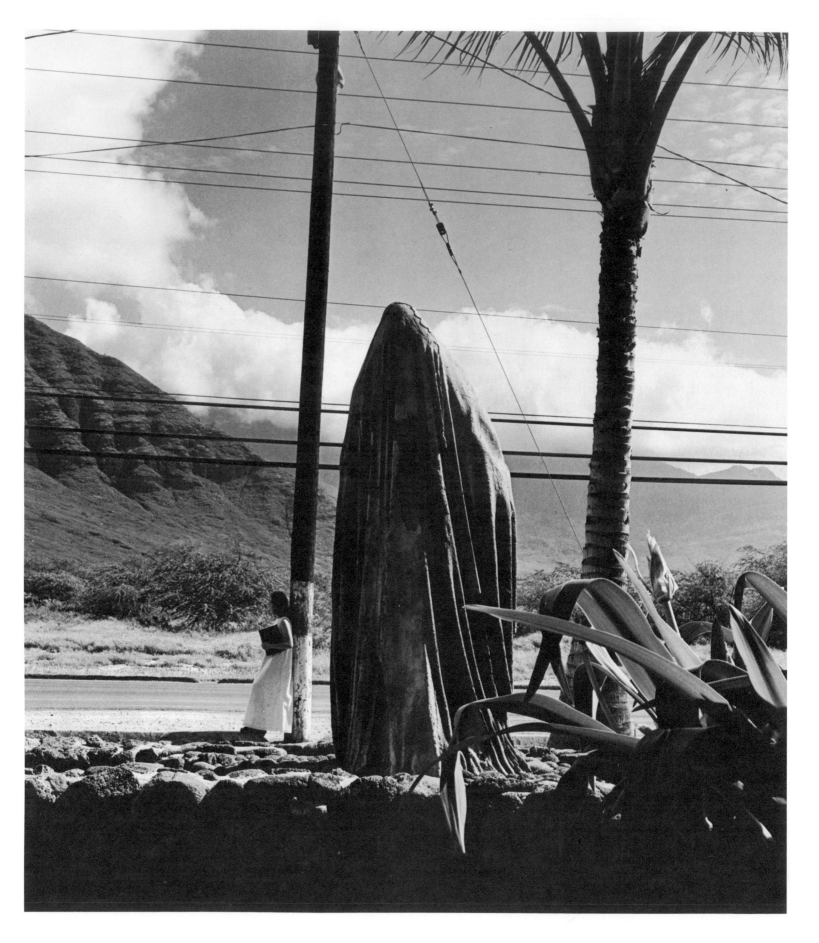

Biographies of the Artists

Biographical material on the artists has been greatly condensed. The exhibitions, collections, and commissions of the artists that are mentioned here represent, in most cases, only a few selections from the complete listing.

Satoru Abe

Born 1926, Honolulu, Hawaii. Went to Art Students League, New York, in 1948. Between several trips to Hawaii, he travelled and exhibited in Japan, returning to New York in 1956, where he joined the Sculpture Center. Awarded Guggenheim Grant in 1963. In Hawaii since 1970, he has participated in artists-in-residence programs on Oahu and the island of Hawaii. His work has been widely shown throughout the Islands and is in numerous private collections. Major commissions include sculpture for Nanakuli High School, Honolulu Community College, Honolulu International Airport, and Leeward Community College. His home and studio is in Makaha on Oahu's Waianae coast.

Bumpei Akaji

Born 1921, Kauai, Hawaii. In Army during World War II. Discharged in Florence, Italy, and enrolled in Academy of Fine Arts. Continued studies in Milan in 1947. Later awarded Fulbright Grant for further study in Italy. M.F.A. from University of Hawaii, 1951. Exhibits include Princess Kaiulani Hotel, Honolulu, 1956; Honolulu Academy of Arts, 1965; Wailoa Center, Hilo, Hawaii, 1975. Numerous commissions throughout the islands. On Oahu: Armed Forces War Memorial, The Bishop Trust, Ala Moana Center, Honolulu International Center, and Ewa Beach Library. Akaji lives and works in Honolulu.

Jay Anderson

Born 1939, Seattle, Washington. Bachelor of Architecture from University of Washington, Seattle, 1962. Lecturer, University of Hawaii, Department of Architecture, 1971–1973. Member of American Institute of Architects. Currently a practicing architect in Honolulu.

David Asherman

Born 1917, New York City. Educated Art Students League, George Grosz Studio, Columbia University, and New York University, New York; Universities of Warsaw and Krakow, Poland; and University of Hawaii. Has had active and diversified career in the arts. During World War II, served as war artist and combat observer in the South Pacific. Scenic designer for theater groups in Maine, New York, Greece, and Hawaii. Has been newspaper columnist, art critic, and art editor for New York and Maine papers and the *Honolulu Advertiser,* for which he was art editor in 1968. Teaching career has been varied: head of Art Department, American School in Paris, 1963–1964; University of Hawaii (workshops in theater design), Honolulu Academy of Arts, and classes at several correctional institutions. Was Artist in Residence, American Samoa, 1972–1973. Founder and director of Contemporary Art Center of Hawaii, 1961. President of Hawaii Painters and Sculptors League. Served on board of directors, Art Students League. His work has appeared in one-man and group shows in the United States, Poland, Paris, and Australia. His commissions include: Greek Orthodox Church frescoes, Chios, Greece (with J. M. Fraser); murals for Ala Moana Hotel, Fort Shafter, Palama Settlement; and project coordinator for Benjamin Parker School mural.

Marguerite Blasingame

Born Marguerite Louis 1906, Honolulu, Hawaii. B.A. from University of Hawaii. M.A. in Art, Stanford, 1928. She has retained her husband's name professionally. Works in a variety of media but primarily in stone and wood. Her commissions in Honolulu include: McCoy Pavilion, Ala Moana Park; carved wood panels, Church of the Crossroads; fountain carvings at Kawananakoa School; façade bas-reliefs on old Water Supply Building;

School, 1974, where he created an eighty-foot three-dimensional ceramic wall sculpture. Other commissions include: Red Hill Elementary School playsculpture, ceramic tile floor mural, Waikiki Aquarium; fountain, Ala Moana Center. Lives in Kaneohe, Oahu, where he maintains his studio.

Herb Kawainui Kane

Born 1928, Waipio Valley, island of Hawaii. Joined Navy at the age of seventeen. Studied anthropology. Attended Art Institute of Chicago, with M.A. in art education from University of Chicago. Lived in Chicago for nearly ten years, working in advertising and in book and architectural design. Returned permanently to Hawaii in 1971. As a noted specialist and illustrator of Polynesian culture, his work has appeared in many exhibits and publications, such as *National Geographic,* December 1974. Recent one-man show held in Lieutenant Governor's Chambers, Hawaii State Capitol. Canoes of Polynesia Collection at Windward Community College Library. Designer of the Polynesian Voyaging Society's twin-hulled sailing canoe, *Hokule'a.*

Alexander Liberman

Born 1912, Kiev, Russia. Early schooling in England. Attended the Sorbonne, where he received his B.A., 1930. Studied painting with Andre Lhote. Also studied at Ecole Spéciale d'Architecture and Ecole des Beaux-Arts, 1931–1932. In 1933, became art director, then managing editor of *Vu* magazine. Left Europe in 1940 and become American citizen, 1946. Joined Condé Nast publications. Wrote several books. In 1962, became editorial director of all Condé Nast Publications. First one-man show in photography, Museum of Modern Art, New York, in 1959. Subsequently, numerous one-man shows in New York in painting and sculpture, through the 1960s and 1970s. Other

exhibits in London, 1964; Naples, 1965; Corcoran in Washington, D.C., 1970; and Honolulu Academy of Arts, 1972. Included in public collections throughout the United States. Lives in New York City.

Jacques Lipchitz

Born 1891, Lithuania. Went to Paris 1909–1911, where he studied at the Ecole des Beaux-Arts, and Académies Julian and Collarossi. Made his first cubist sculpture, 1914. First one-man show, 1920, at Léonce Rosenberg's Gallery, Paris. In 1935, large exhibition at Brummer Gallery, New York. Moved to New York in 1941. During his distinguished career, his work has been exhibited extensively throughout Europe and the United States. Major retrospectives include: Galerie de la Renaissance, Paris, 1930; Museum of Modern Art, New York, 1954; UCLA, 1963; Metropolitan Museum, New York, 1972. Awards include Gold Medal, American Academy of Arts and Letters, 1966; Medal of Achievement, A.I.A., 1966. A few major commissions: Brazilian Ministry of Health and Education, 1943; Fairmount Park Association, Philadelphia, 1960; Los Angeles County Music Center, 1969. Died in 1973, on Capri.

Marisol

Born Marisol Escobar, 1930, in Paris, of Venezuelan parents. Began art studies in Paris, Ecole des Beaux-Arts and Académie Julian. Went to New York City, 1950. Attended Art Students League, 1950; New School for Social Research, 1951–1954; and Hans Hofmann School, 1954–1956. Influenced by Jasper John and Robert Rauschenberg. First exhibit at Leo Castelli Gallery, New York, 1957, followed by shows at Stable Gallery and Sidney Janis Gallery during the 1960s. Has been in numerous group exhibitions throughout Europe and the United States. Her works are

represented in many permanent collections: Brandeis University, Museum of Modern Art and Whitney Museum, New York; Albright-Knox, Buffalo. Well-known works: *The Party* and *The Dealers,* 1965–1966, large assemblages of figures. Lives in New York City.

Eli R. Marozzi

Born Montegallo, Italy, 1913. Early travels in India heightened interest in Indian art and philosophy. B.A., 1949, University of Washington. Studied with Mark Tobey during this time. Moved to Hawaii, obtaining M.A. in art, University of Hawaii, 1952. Has exhibited frequently in group shows at Honolulu Academy of Arts and Honolulu Hale; Hawaii Painters and Sculptors League Annuals; Seattle Art Museum. Show with Madge Tennent at Contemporary Art Center, 1962. Has taught in the Y.W.C.A. Adult Education Program since 1950. Recent commissions include those for Leeward Community College and St. Philomena Church, Salt Lake, Oahu, Hawaii.

Ivan Mestrovic

Born Dalmatia, Yugoslavia, 1883. Was a shepherd during childhood. Apprenticed to a stonecarver in Split. First one-man show in Belgrade, 1904. Attended Fine Arts Academy in Vienna, 1901–1904, and studied in Paris from 1907 to 1909, where he was encouraged by Rodin and Bourdelle. Exhibited Salon d'Autonne, 1908. During this period, produced nearly fifty more-than-life-sized sculptures. Exhibited Vienna Secession Group, 1909. After World War I, settled in Zagreb, where he became an important teacher and cultural leader. Many significant one-man shows were held during the 1920s and 1930s in his own country, London, Paris, New York, and other major American cities. Moved to United States in 1947 and became professor of sculpture,

University of Syracuse, 1947–1955. Exhibition at Metropolitan Museum, New York, 1947, was first one-man show held there for a living artist. Major themes for his prodigious output of sculpture are concerned with great heroes, the struggle for freedom and, later, religion. Became American citizen, 1954. From 1955 until his death in 1962, was professor of sculpture, Notre Dame University, Indiana. Recipient of many honorary doctorates and awards. Collections of his work: Mestrovic Gallery, Split; and Mestrovic Museum, Zagreb, in Yugoslavia; and museums throughout the world.

William Mitchell

Born 1925, London, England. Educated University of Southampton, and Royal College of Art, London; British School at Rome. Interest in medieval crafts and modern building materials influenced his professional direction. Began career as consultant to London County Council on state housing and subways. Works in large scale in concrete, glass, metal, for civic buildings, schools, and churches. Commissions include: Niu Valley Intermediate School, Honolulu; Wall reliefs for BART stations, San Francisco Bay Area; Great Doors for Liverpool Cathedral, and Stations of the Cross, Bristol Cathedral. Lives in London.

Kay Mura-Davidson

Born 1942, Denson, Arkansas. Received B.A., art history, from Pomona College, California, in 1964. M.A., sculpture, 1965, and secondary teaching credential, 1966, from Claremont College, California. M.F.A., ceramics, from University of Hawaii, 1970. Since 1973, has been an instructor in ceramics, Leeward Community College, Oahu. Has exhibited in California and New York, with many shows in Hawaii. Member of Hawaii Painters and Sculptors League and of Hawaii Craftsmen. Participant in

Artists-in-Residence Program on island of Hawaii, 1975. Commissions include sculpture for Hawaii School for Deaf and Blind and Likelike School, Honolulu; Waimea Elementary and Intermediate School, Kamuela, Hawaii; and the Fort DeRussy hotel, Hale Koa.

Otto Piene

Born 1928, Westphalia, Germany. Studied at Academy of Fine Art, Munich, 1948–1950; Academy of Fine Arts, Dusseldorf, 1950–1953. Degree in philosophy from University of Cologne, 1957. Cofounder, Group Zero, Dusseldorf, 1957, and prominent participant in their shows. Innovative experiments in various media; first smoke painting, light performance, 1959. First fire paintings and automated programmed light machines, 1960. First hot air balloon demonstration, 1961. Many one-man shows and group exhibits in Europe and the United States. Major light sculpture and environmental commissions include kinetic light sculpture for façade of Wormland Department Store, Cologne, 1966; light sculptures for senate and house of representatives chambers, State Capitol, Honolulu, 1970; prism wall sculpture, University of Hawaii, 1976. Visiting professor, lecturer at many universities and art institutions. Fellow, Center for Advanced Visual Studies, M.I.T., Cambridge, Massachusetts, since 1968.

William D. Podesto

Born 1938, Modesto, California. Educated State Polytechnic College, California. B.S. in architectural engineering, 1963. M.B.A., Golden Gate College, San Francisco, 1973. Practicing architect, Hawaii, 1970–1972. Currently practices in San Francisco. Member of American Institute of Architects.

Arnaldo Pomodoro

Born 1926, Morciano di Romagna, Italy. Studies and early career were in stage design, architectural and jewelry design. First important sculpture shows in Florence and Milan, 1954. Recipient of many exhibition awards, including São Paulo Biennale, 1963; Venice Biennale, 1964; and Carnegie Institute's "1967 Pittsburgh International." Numerous exhibitions, including: Musée d'Art Moderne, 1959, and Grand Palais, 1963, Paris; Felix Landau Gallery, Los Angeles, 1962; Marlborough Gallery, London, 1962; Dallas Museum, 1965. His works are included in collections of: Tate Gallery, London; Museo de Bellas Artes, Buenos Aires; Museum of Modern Art, New York; Phoenix Museum, Arizona, among others. Commissions include: Financial Plaza of the Pacific, Hawaii; Rank Xerox, Milan; Cologne Popular University, and Spoleto, Italy.

Alfred Preis

Born 1911, Vienna, Austria. Graduated from Vienna Institute of Technology, 1938. Moved to Hawaii, 1939, and began practicing architecture. Became member of A.I.A., 1941, and American citizen, 1946. Fellow of A.I.A., 1965. State Planning Coordinator since 1963. Became executive director of the State Foundation on Culture and the Arts, 1966. Drafted and assisted Legislative Reference Bureau in developing bill known as Act 298, which set aside one percent of all appropriations for state buildings for acquisition or commissioning of works of art for the public. Has been continually active on numerous committees concerned with the arts, planning, and environmental issues. Among awards, A.I.A. Honor Awards for U.S.S. *Arizona* War Memorial, 1962, and Special Citation for Contribution to the Environment, 1972.

Bernard Rosenthal

Born 1914, Highland Park, Illinois. B.F.A. University of Michigan, 1936. Worked at Cranbrook Academy of Art, 1939–1940. After serving in army, moved to Los Angeles. Taught at UCLA, 1953. Established studio in New York, 1960. Numerous one-man exhibits across the United States, including: M. Knoedler & Company, Kootz Gallery and Associated American Artists Galleries in New York; Carnegie Institute, Pittsburgh; San Francisco Museum of Art. His work has been extensively represented in group shows, among others: Whitney Museum, Museum of Modern Art, and Metropolitan Museum of Art, New York; Art Institute of Chicago; Walker Art Center, Minnesota. Major commissions include Department of Parks, and New York Public Library, New York; University of Michigan; I.B.M. Building, Los Angeles; Civic Downtown Malls, Fresno, California; and Financial Plaza of the Pacific, Hawaii. Lives in New York.

Mamoru Sato

Born 1937, El Paso, Texas. B.A., fine arts, 1963, and M.F.A., sculpture, 1965, University of Colorado. Taught at University of Colorado, 1963–1965. Moved to Hawaii in 1965 to teach sculpture at University of Hawaii; since 1974 has been associate professor of sculpture. One-man shows in Honolulu at Gima's Art Gallery, 1966, 1969; Contemporary Art Center, 1968; University of Colorado, 1968. Participant in numerous annual shows in Honolulu. Commissions include sculpture for Kona State Office Building, Hawaii; Honolulu International Airport; Honolulu Community College Library; James Michener Collection, Pipersville, Pennsylvania; and Hayashide Onsen Hotel, Kagoshima, Japan.

Tadashi Sato

Born 1923, Kaupakalua, Maui. Began art studies at Honolulu Academy of Arts. In 1948 went to New York to study at Brooklyn Museum Art School, then Pratt Institute and New York School for Social Research. From 1950 to 1960 travelled back and forth from Hawaii to New York, with one year in Japan. Numerous one-man shows include Gallery 75, New York; McRoberts and Tunnard Gallery, London; Richard White Gallery, Seattle; Contemporary Arts Center and Honolulu Academy of Arts, Hawaii. Group exhibitions have been held at Guggenheim, Whitney, and Museum of Modern Art, New York; Albright Art Gallery, Buffalo; and de Young Museum, San Francisco, among others. Major mural commissions: War Memorial Center and Kahului Library, Maui; Aina Haina and Aiea branch libraries on Oahu; and mosaic, Hawaii State Capitol. Since 1960 he has lived in Lahaina, Maui.

Ken Shutt

Born 1928, Long Beach, California. Attended Pasadena City College, then Art Center School and Chouinard Art Institute, Los Angeles. Moved to Hawaii, 1963. Some of his commissions in the islands include: Hawaiian Air Academy, American Savings and Loan Association, Sea Life Park on Oahu; Laupahoehoe School on Hawaii. His works have been included in group exhibits of the Watercolor and Serigraph Society, Contemporary Art Center, Artists of Hawaii, and Easter Art Festival in Honolulu. His home and studio is in Kahaluu, Oahu.

Edward Stasack

Born 1929, Chicago, Illinois. After four years in the army, received B.F.A., 1955 and M.F.A., 1956, University of Illinois. Moved to Hawaii 1956, as instructor in art, University of Hawaii, where he is currently professor of art. Award of Tiffany Foundation Fellowships, among others, allowed him to continue studies of Hawaiian petroglyphs. Collaborated with J. H. Cox on *Hawaiian Petroglyphs,* published 1970. One-man shows of paintings held Honolulu Academy of Arts, 1963, 1967, 1969; Downtown Gallery, New York, 1965; and Downtown Gallery, Honolulu, 1974. Exhibited in printmaking biennials in Poland, Yugoslavia, Buenos Aires, Argentina, Manila, Tokyo, Paris, and Mexico. Commissions in Hawaii include Fort Street Mall murals and Honolulu Community College mural. Lives in Honolulu.

Harold Tovish

Born 1921, New York City. Studied at Columbia University, 1940–1943; Ossip Zadkine School of Sculpture, 1949–1950; Académie de la Grande Chaumière, Paris, 1950–1951. Has had an extensive teaching career: New York State College of Ceramics, 1947–1949; University of Minnesota, 1951–1954; Museum of Fine Arts, Boston, 1957–1965; M.I.T., 1967–1968; visiting professor of sculpture, University of Hawaii, 1964, 1970. Sculptor-in-residence at American Academy, Rome, 1965. Currently professor of sculpture and drawing, Boston University. Elected Fellow, Center for Advanced Visual Studies, M.I.T., 1968. Has exhibited widely. One-man shows include Walker Art Center, Minneapolis; Swetzoff Gallery, Boston; Terry Dintenfass Gallery, New York. Group exhibitions include Whitney Museum and Museum of Modern Art, New York; Venice Biennale; Guggenheim International Award Exhibition, among others. Lives in Brookline, Massachusetts.

George Tsutakawa

Born 1910, Seattle, Washington. Educated Japan, 1917–1927. B.A., M.F.A., University of Washington,

1937. Served in the army 1942–1946. Has been on faculty of University of Washington since 1947, where he is currently professor of art. Extensive travelling during the past thirty years. Over thirty-five fountain-sculpture commissions since 1960, including those for the Ala Moana Center, Hawaii; Civic Malls, Fresno, California; National Cathedral, Washington, D.C.; Bentall Center, Vancouver, British Columbia. Exhibitions of his work include Seattle Art Museum; San Francisco Museum of Art; de Young Museum, San Francisco; International Art Festival, Berlin, East Germany; Expo '70, Osaka, Japan. Many awards, including Design Award, A.I.A., 1960, and Governor's Award of Commendation, State of Washington, 1967. Lives in Seattle.

Tom Van Sant

Born 1931, Los Angeles, California. M.A., Stanford University; M.F.A., Otis Art Institute, California. Taught drawing and design, Otis Art Institute 1961–1967. Many major sculpture commissions, including: Pacific Davies Center, Honolulu International Airport, Yacht Harbor Towers, Honolulu; Civil Aeronautic Administration, Taipei, Taiwan; forty sculptural walls for Irvine Financial Plaza, Newport Beach, California. Lives in Los Angeles, California.

George Walters

Born 1926, Honolulu. B.A., architectural design, 1952, and M.S., landscape architecture, 1954, University of California, Berkeley. Engaged in private practice in Honolulu until his death in 1976. Member of American Society of Landscape Architects. Taught courses in landscape architecture at Honolulu Y.W.C.A., McKinley High School, and University of Hawaii. Guest lecturer for many organizations in Honolulu. Served on numerous civic advisory committees relating to planning, beautification,

and conservation issues in Hawaii. Among his many commissions: Hawaii State Library sculpture garden; play-sculpture in Kapiolani Park; River Street Mall; Queen Emma Gardens; and Amfac Building roof garden.

Charles Watson

Born 1915, Guelph, Ontario, Canada. Attended Santa Monica City College, 1935–1937. Moved to Hawaii, 1946, after serving in U.S. Navy. Began successful career in construction business. Currently he is chairman of the board of Hawaii Dredging and Construction Company. In 1959, his interest in sculpture led to his first works in welded steel. Among his commissions: University of Hawaii, Sea Life Park, and Ala Moana Center. One-man shows have been held at Hawaiian Savings and Loan Gallery, 1969, and Contemporary Art Center of Hawaii, 1975. His work has been included in group shows of Artists of Hawaii and Ala Moana Easter Art Festival. His home and studio is in Kaneohe, Oahu.

John Wisnosky

Born 1940, Springfield, Illinois. B.F.A., M.F.A. in painting and printmaking, University of Illinois. Taught at Virginia Polytechnic Institute and University of Illinois. Began teaching University of Hawaii, 1966, where he is currently associate professor of art. Numerous one-man shows include: Honolulu Academy of Arts, Gima's Art Gallery, and Downtown Gallery, Honolulu; Boston Museum of Fine Arts; Virginia Polytechnic Institute. Group exhibitions include: Chicago Art Institute, 1964; Ohio University, 1965; Otis Art Institute, California, 1968; University of Illinois, 1970; Expo '74, Spokane, Washington. Among awards received: Society of American Graphic Artists, New York, 1965; Boston Printmakers, 1965; Western Washington State College, 1967, as well as many grants and

scholarships. Sculpture commissions include works for Moiliili Public Library and Campbell High School, Ewa Beach, Honolulu. Lives in Honolulu.

Bibliography

A Decade of Design. Honolulu: Hawaii Chapter, American Institute of Architects and State Foundation on Culture and the Arts, 1969.

Adler, Jacob. "The Kamehameha Statue." *Hawaiian Journal of History* 3(1969).

American Federation of Art. *Who's Who in American Art.* New York: R. R. Bowker, 1973.

Arnason, H. H. *Jacques Lipchitz: Sketches in Bronze.* New York: Praeger, 1969.

Beckwith, Martha. *Hawaiian Mythology.* Honolulu: University of Hawaii Press, 1970.

Burnham, Jack. *Beyond Modern Sculpture.* New York: George Braziller, 1968.

Cox, Halley J., and Davenport, William H. *Hawaiian Sculpture.* Honolulu: The University Press of Hawaii, 1974.

Cummings, Paul. *Dictionary of Contemporary Artists.* 2d ed. New York: St. Martin's Press, 1971.

Daws, Gavan. *Shoal of Time.* Honolulu: The University Press of Hawaii, 1974.

DeFrancis, John. *Things Japanese in Hawaii.* Honolulu: The University Press of Hawaii, 1973.

Fairfax, Geoffrey. *The Architecture of Honolulu.* Honolulu: Island Heritage, Ltd., (n.d.).

Feher, Joseph. *Hawaii: A Pictorial History.* Honolulu: Bishop Museum Press, 1969.

Forgey, Benjamin. "A New Vision: Public Places with Sculpture." *Smithsonian* 6 (October 1975):50–57.

Haar, Francis, and Neogy, Prithwish. *Artists of Hawaii.* Honolulu: State Foundation on Culture and the Arts and The University Press of Hawaii, 1974.

Hammacher, A. M. *Sculpture of Barbara Hepworth.* New York: Abrams, 1968.

Honolulu Academy of Arts: reference material.

Honolulu Advertiser.

Honolulu Star-Bulletin.

Hunter, Sam, and Jacobs, John. *American Art of the Twentieth Century.* Englewood Cliffs, New Jersey: Prentice-Hall, 1975.

Kečkemet, Duško. *Ivan Mestrovic.* New York: McGraw-Hill, 1970.

The King Kamehameha I and Father Damien Memorial Statues. Honolulu: State of Hawaii Statuary Hall Commission, 1970.

Lee, Robert M., ed. *The Chinese and Hawaii.* Honolulu: Chinese Chamber of Commerce, 1961.

Licht, Fred. *Sculpture of the Nineteenth and Twentieth Centuries.* Greenwich, Connecticut: New York Graphic Society, 1967.

Lipchitz, Jacques, with Arnason, H. H. *Documents of Twentieth Century Art: My Life in Sculpture.* New York: Viking Press, 1972.

Marlborough-Gerson Gallery, Inc. *Arnaldo Pomodoro.* 1965 catalogue.

Mulholland, John F. *Hawaii's Religions.* Rutland, Vermont and Tokyo: Charles E. Tuttle, 1970.

Oakland Museum. *Public Sculpture/Urban Environment.* 1974 catalogue.

Old Honolulu. Honolulu: Historic Building Task Force, 1969.

Ritchie, Andrew Carnduff. *Sculpture of the Twentieth Century.* New York: Museum of Modern Art, 1952.

Sales Builder.

Selz, Jean. *Modern Sculpture.* New York: Braziller, 1963.

State Foundation on Culture and the Arts: reference material.

State Foundation on Culture and the Arts. *Annual Reports: Fiscal Years 1972–1973; 1973–1974.* Honolulu.

University of Illinois. *Contemporary American Painting and Sculpture,* 1959, 1961, 1963, 1967 eds. Catalogue.

Walker Art Center. *Twentieth Century Sculpture.* 1969 catalogue.

About the Authors

Georgia F. Radford was educated at Vassar College and the University of California, Berkeley, where she received her bachelor's degree in English. She has been a long-time member of the Art League of the East Bay and an art docent with the Oakland Museum. Presently she is a painting acquisition chairperson for the rental program of the Collectors Gallery of the Oakland Museum. While living in Hawaii from 1974 to 1975, she was an art docent at the Honolulu Academy of Arts.

Warren H. Radford, A. I. A., received his bachelor's degree in fine arts at Harvard College and his master's degree in architecture from the Harvard School of Design. He holds a master of public health degree from the University of Hawaii. His professional practice of architecture, primarily in the field of educational and medical facilities, has been in the San Francisco Bay area. He and Mrs. Radford make their home in Berkeley, California.

About the Photographer

Rick Golt is a graduate of Miami University, Oxford, Ohio. He was a flyer with the U.S. Navy for six years and a pilot navigator with Pan American Airlines for two years before beginning a full-time photography career in 1967. His one-man show in 1973 was the first in photography to be held at the Contemporary Arts Center of Hawaii. He specializes in photographic art commissions and has done work for local, national, and international firms. He is the photographer-author of *Hawaiian Reflections* (1972) and the photographer for the series of books, *The Hawai'i Garden,* by Horace F. Clay and James C. Hubbard.

Photography Notes

All photographs in this book are the work of Rick Golt, with the following exceptions: the panel of the State Capitol demonstration at the United Public Workers Building, courtesy Mr. Stephen Murin; and the reproduction of the Louis Choris watercolor, courtesy the Honolulu Academy of Arts.

All photography was done with Hasselblad equipment to obtain highest detail and resolution and still afford mobility to capture the essence of spontaneous action in the environment. Most photographs were made with 80mm and 50mm lenses, although 150mm and 250mm were used on occasion. Film was Plus-X professional, with Tri-X used in some situations. All subjects were approached with the intent to portray accurately the artists' works and their interaction with the environment.

Production Notes

This book was designed by Richard Hendel. Composition was done on the Unified Composing System by the design and production staff of The University Press of Hawaii. The typeface for text and display is Garamond. Offset presswork and binding were done by Kingsport Press. Text paper is Warren's White Patina Matte Book, basis 70.